EXPRESSIVE ANATOMY FOR COMICS AND NARRATIVE

The Will Eisner Library
from W. W. Norton & Company

HARDCOVER COMPILATIONS
The Contract With God *Trilogy: Life on Dropsie Avenue*
Will Eisner's New York: Life in the Big City
Life, in Pictures: Autobiographical Stories

PAPERBACKS
A Contract With God
A Life Force
Dropsie Avenue
New York: The Big City
City People Notebook
Will Eisner Reader
The Dreamer
Invisible People
To the Heart of the Storm
Life on Another Planet
A Family Matter
Minor Miracles
The Name of the Game
The Building
The Plot: The Secret Story of the Protocols of the Elders of Zion

EXPRESSIVE ANATOMY FOR COMICS AND NARRATIVE

PRINCIPLES AND PRACTICES FROM THE LEGENDARY CARTOONIST

WITH PETER POPLASKI

W. W. NORTON & COMPANY
NEW YORK · LONDON

A Will Eisner Instructional Book

For information about permission to reproduce selections from this book,
write to Permissions, W. W. Norton & Company, Inc.,
500 Fifth Avenue, New York, NY 10110

For information about special discounts for bulk purchases, please contact
W. W. Norton Special Sales at specialsales@wwnorton.com or 800-233-4830

Manufacturing by RR Donnelley, Willard
Book design by Grace Cheong, Black Eye Design, blackeye.com
Production manager: Devon Zahn
Digital production: Sue Carlson, Joe Lops, and Alex Price

Produced in Association with:
The Center for Cartoon Studies
White River Junction, Vermont
cartoonstudies.org

Library of Congress Cataloging-in-Publication Data

Eisner, Will.
Expressive anatomy for comics and narrative : principles and practices from the legendary
cartoonist / Will Eisner with Peter Poplaski. —1st ed.
p. cm.
ISBN 978-0-393-33128-8 (pbk.)
1. Comic books, strips, etc.—Authorship. 2. Cartooning—Technique.
I. Poplaski, Peter. II. Title.
PN6710.E56 2008
741.5′1—dc22
 2008019797

W. W. Norton & Company, Inc.
500 Fifth Avenue, New York, N.Y. 10110
www.wwnorton.com

W. W. Norton & Company Ltd.
15 Carlisle Street, London W1D 3BS

8 9 10 11 12

CONTENTS

Contents

EDITOR'S NOTE

WILL EISNER SELF-PUBLISHED MULTIPLE PRINTINGS OF HIS FIRST TWO INSTRUCTIONAL books, *Comics and Sequential Art* and *Graphic Storytelling and Visual Narrative*. It had long been his intention to complete the trilogy with *Expressive Anatomy for Comics and Narrative*. He first tackled the topic with an article in *The Spirit Magazine* #29 (1981), which became the basis of a chapter titled "Expressive Anatomy" in *Comics and Sequential Art* (1985), but he felt the subject was important enough to expand into a volume of its own.

In late 2004 Eisner was planning *Expressive Anatomy* as his next major project while simultaneously finishing *The Plot* for W. W. Norton and creating a short "Spirit" contribution to Michael Chabon's *Escapist* comic book series (Dark Horse). Near the year's end Eisner had written the first draft and prepared a "dummy" of *Expressive Anatomy*. He selected many of the pre-existing images, by himself and others, to illustrate aspects of the book, and he had penciled nearly all of his new illustrations, anticipating the volume's completion by the following spring.

Toward the end of December Will Eisner was hospitalized after experiencing chest discomfort and soon afterward underwent heart surgery. In early January 2005, following complications, he died, not long before his eighty-eighth birthday. Though technically an old man, Will had been so productive for so long, and so young in spirit and thought, that many of us were shocked by his passing.

Eisner's family and I determined that *Expressive Anatomy* was close enough to completion that it should be finished. Peter Poplaski, an artist Eisner had long worked with and trusted, was engaged to finish the posthumous work. As both the longtime art director at Kitchen Sink Press and as a freelancer, Poplaski had designed and/or colored numerous covers for Eisner's graphic novels and collections and *Spirit* comic books and magazines. He penciled the wraparound cover to the Spirit "jam" issue of *Spirit* magazine (#30, 1981) that seven artists, including Eisner and Poplaski, inked. Poplaski also drew a cover for *The Spirit: The New Adventures* series and, most recently, inked Eisner's new penciled illustrations for *Will Eisner's New York* (Norton, 2006) and designed the cover to Eisner's *Life, in Pictures* (Norton, 2007).

Readers with a sharp eye will be able to distinguish Poplaski's inks from the illustrations both penciled and inked by Eisner in this volume, but his brushwork masterfully captures the nuance and expression inherent in Eisner's underdrawings. In addition to his artistic contribution, Poplaski helped shape the final wording of the text, particularly where only an outline or rough draft existed. He listened to many hours of lectures and interviews in order to extract Eisner's own words where there were gaps in *Expressive Anatomy*.

Margaret Maloney provided additional valuable editorial assistance, with oversight from Norton editors Robert Weil and Lucas Wittmann. At Black Eye Design, Michel Vrana worked with Grace Cheong to redesign the other Norton editions of this trilogy and give this first edition its final look. The continuing guidance and ultimate approval of the estate, primarily Ann Eisner and Carl and Nancy Gropper, was at all times appreciated. The teamwork was essential in completing the final work of an illustrious artist, storyteller and teacher.

Denis Kitchen

—Denis Kitchen

Editor's Note

INTRODUCTION

GRAPHIC NARRATIVE MAY BE DEFINED AS THE EMPLOYMENT OF WORDS AND VISUAL images in an intelligent and disciplined sequence to explain an idea or tell a story. Artists who cope with this challenge design their work with print or digital reproduction in mind. From my personal experience as a professional comics artist and as a teacher, it is my belief that the function of human anatomy, with an emphasis on its role in the process of emotion and intent, has been sorely neglected by young artists learning the practices of comics and sequential art. This book aims to remedy that neglect by providing a basic guide of body grammar for the depiction of people as characters and their manipulation as actors in the service of a drama.

Traditionally, a book on anatomy is confined to the structure of the human body, but with this book I wish to go beyond muscles and bones. I have always felt that the mind is the primary instigator of human conduct. This premise is arguable, but I believe it is a useful basis for understanding and portraying human motives in storytelling. I offer as support a statement made by the famous biologist Sir Julian Huxley who said: "The brain alone is not responsible for the mind though it is a necessary organ for its manifestation."

This book begins with the mechanical construction of the human figure in common positions using common gestures. Then, examples of emotion and reaction drawn from personal observation are added. Figures function as simple patterns when a scene is initially composed. They are "blocked out," as if in suspended animation, and then modified by expressions and suggested movement.

In this whole process of creating a visual story, the artist functions like a theater director choreographing the action. The expression of human emotion is displayed by behavior articulated by meaningful postures. Often, to achieve a particular expression the gestures may require distortion or exaggeration. To create an idea of individual personality and physical differences, the knowledge of the anatomical structure and the weight of the human body are most important. If he is going to communicate his ideas effectively, an artist must have a complete understanding of the body grammar of the human figure and how to use it.

—Will Eisner

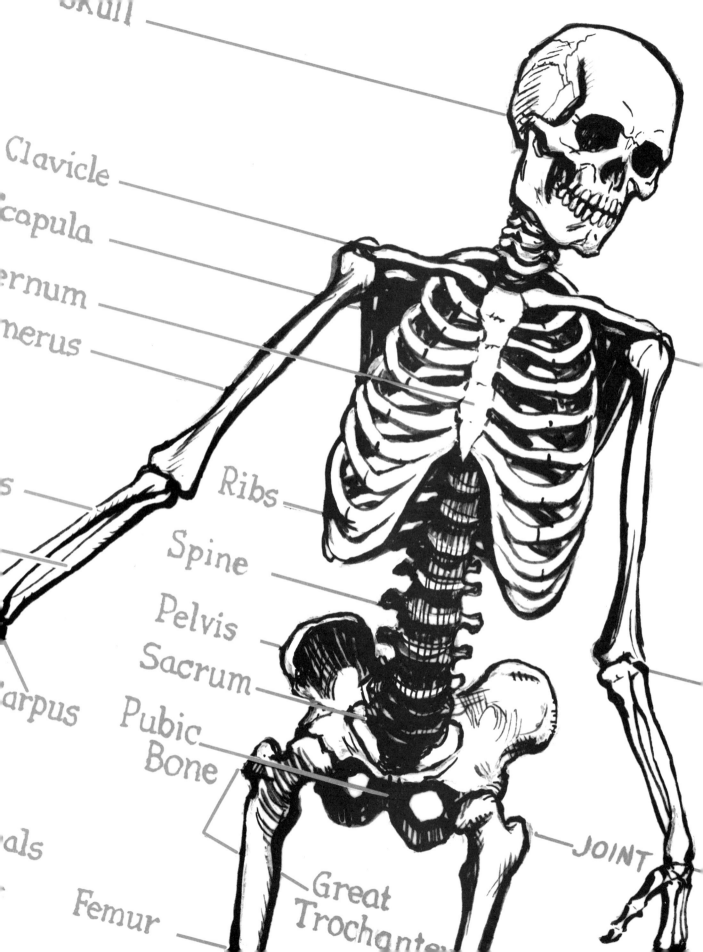

CHAPTER 1

THE HUMAN MACHINE

For effective portrayal of human action, it is advisable to regard the human body as a mechanical structure. The frame upon which the human body is built is the skeleton. It is a series of more than 200 bones connected to each other either by a ball and socket joint, a hinge-like formation, or a fixed attachment. These bones differ in size in respect to height and age and they are grouped and divided among the spine, cranium, face, ribs, and sternum, upper extremities and lower extremities. Their function is to protect the internal organs, bear weight, and act as the tools and levers for movement and operations. To the skeletal structure are attached muscles and tendons, which move the bones to articulate an action. In portraying the motion of the human machine an understanding of the limitations of its connected parts is a major consideration.

According to the basic canon of relative proportions, the classical adult male figure is eight heads high while the adult female figure is often depicted seven and one-half heads high.

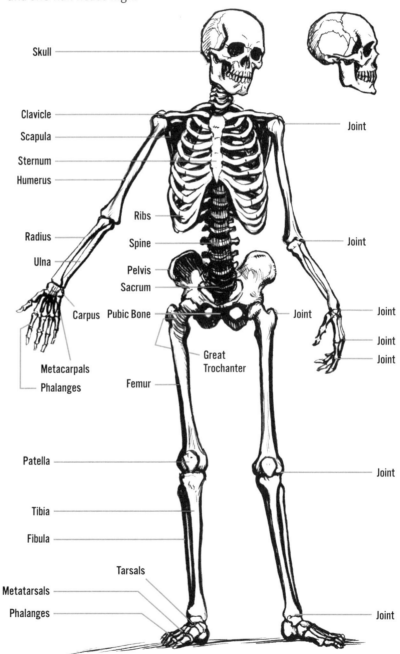

Skull

Clavicle

Scapula

Sternum

Humerus

Ribs

Radius

Spine

Ulna

Pelvis

Sacrum

Carpus Pubic Bone

Metacarpals

Phalanges

Great Trochanter

Femur

Joint

Joint

Joint Joint

Joint

Joint

Patella

Joint

Tibia

Fibula

Tarsals

Metatarsals

Phalanges

Joint

SKELETON BACK

The formula of the ideal canon used to create a balanced, beautiful and symmetrical human figure demands that the measurement between the joints of any limb (shoulder-elbow-hand, or hip-knee-foot) be equidistant.

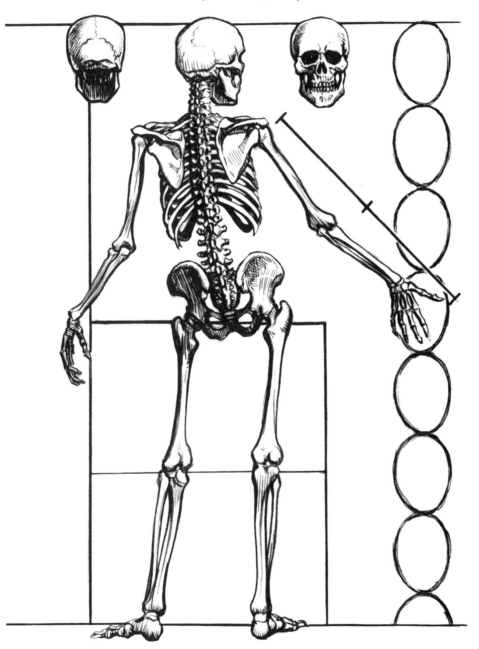

SKELETON SIDE

Likewise, the distance from the top of the cranium to the bottom of the pelvis is the same as the distance from the bottom of the pelvis to the heel of the foot (see image on previous page).

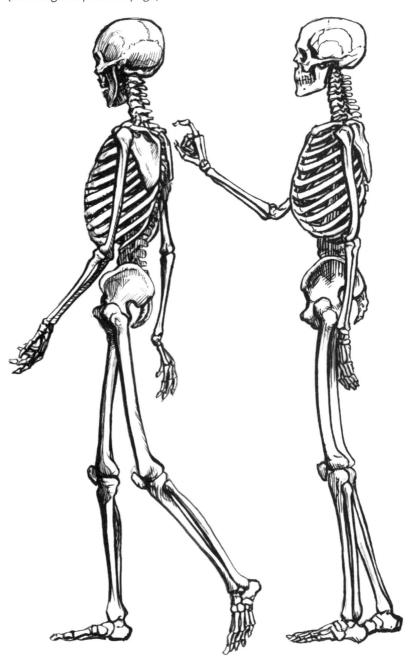

JOINTS

Joints are the connecting points between the skeleton's movable parts. Arms, fingers, ankles, and knees use a hinge system. Hips and shoulders use a ball and socket system.

HINGE A hinge opens and closes. Movements are limited by the maximum and minimum angles each joint can attain.

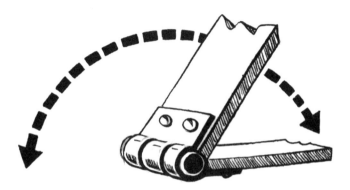

BALL AND SOCKET The ball and socket arrangement permits a wide range of motion in multiple planes, limited by the location of the joint in relation to other bones.

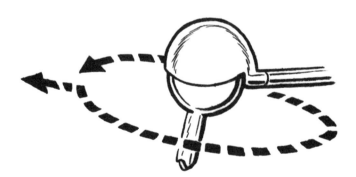

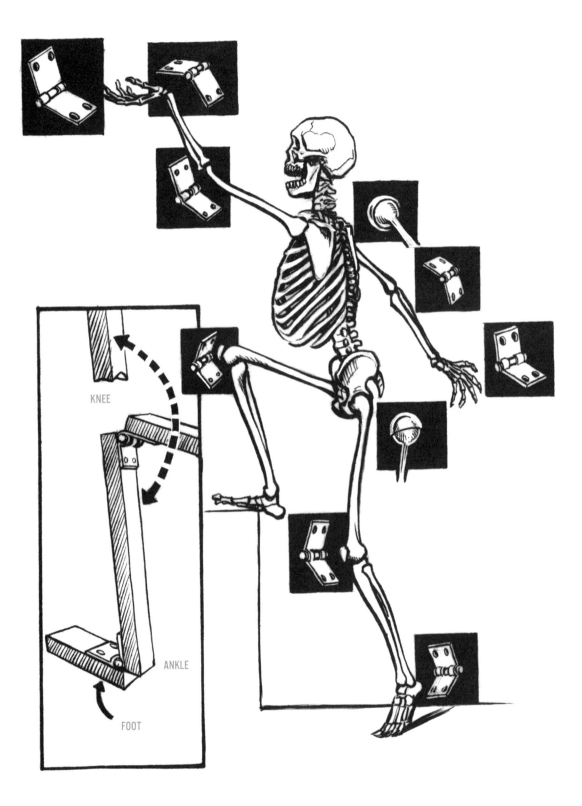

KNEE

ANKLE

FOOT

SHOULDERS

The arms are connected to the shoulders with a ball and socket joint that allows circular and sideways mobility.

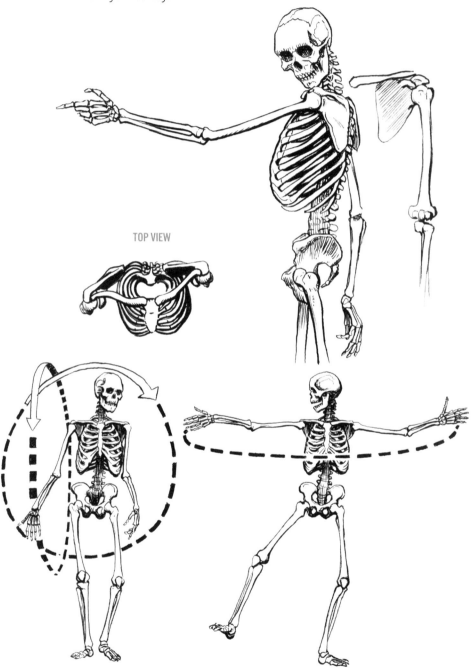

TOP VIEW

LEGS

The leg system is anchored in the pelvis by a ball and socket arrangement with rearward movement interrupted by the pelvis.

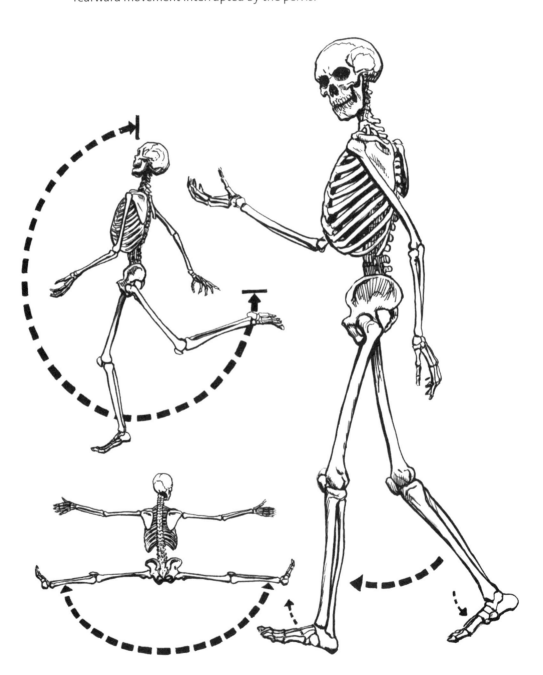

THE TRUNK

The trunk is the combination of the spine and the rib cage that as a total unit is anchored in the pelvis to accommodate bending forward, backward and a modest range of motion from side to side.

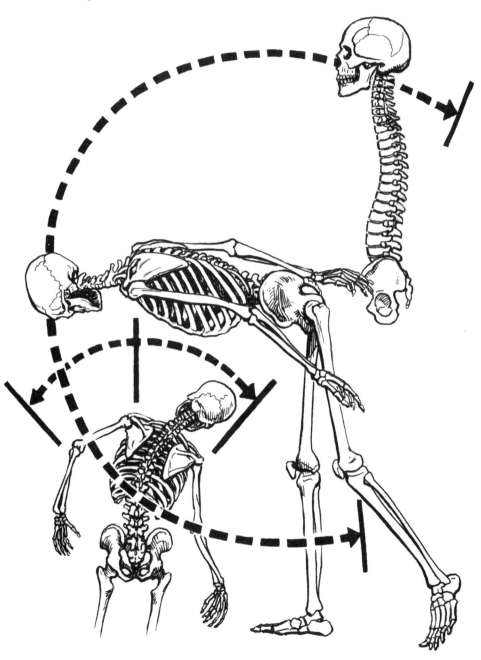

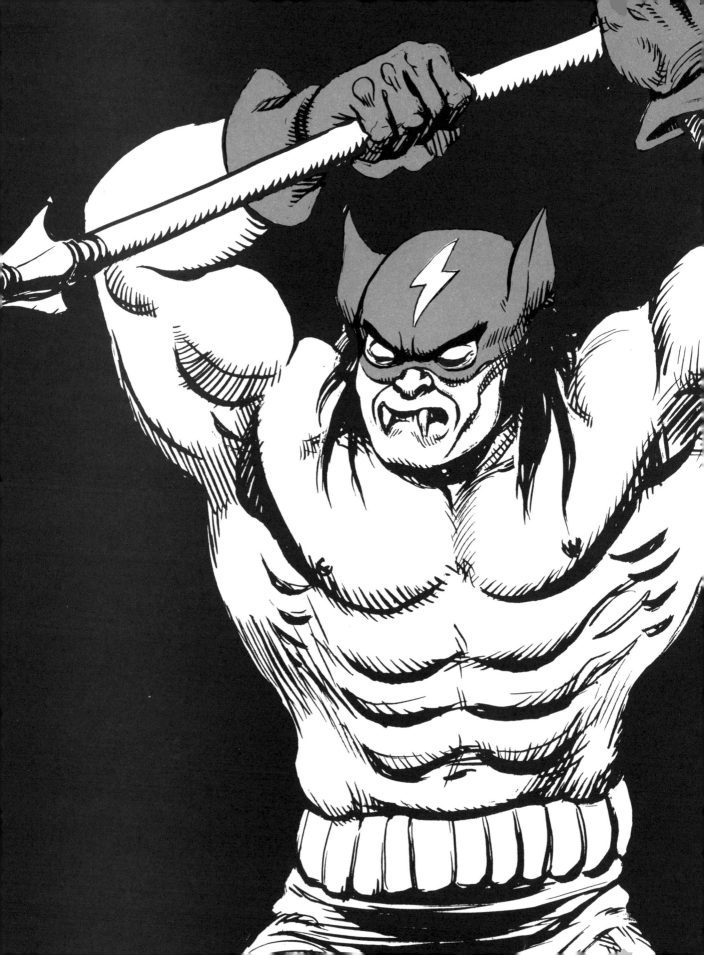

CHAPTER 2

MUSCLES ACTIVATE MOVEMENT

Muscles are bundles of fibers that are attached to bones by firm bands of connective tissue called tendons. Muscles vary in thickness and length. They can be stretched or contracted by an attached muscle. A complex system carries a signal from the MIND to the BRAIN to the MUSCLE which then moves the bones (see page 35).

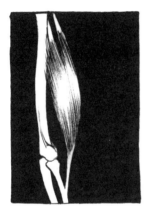 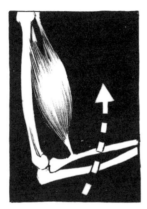 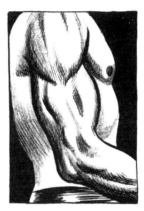

When a muscle contracts or tenses, it uses tendons to pull the bone to which it is attached, and when it relaxes, it releases the bone back to its basic position. Muscles can alter the power of the pulling but are limited by the mechanics of the joint's connection. Likewise, the mechanics of muscles are themselves a limitation on the movement of the skeleton.

MUSCLES AND THE BODY

Muscles, in addition to enabling the body's movement, also give the body definition. Layers of muscles, unlike the tendons which connect them to the bones, are discernible beneath the skin. Just as an artist must know the limitations and structure of the skeleton in order to draw realistic human movement, so too must he know how muscles are arrayed to create a realistic human shape.

Muscles can be enlarged by exercise that serves to increase their power.

MUSCLES FRONT

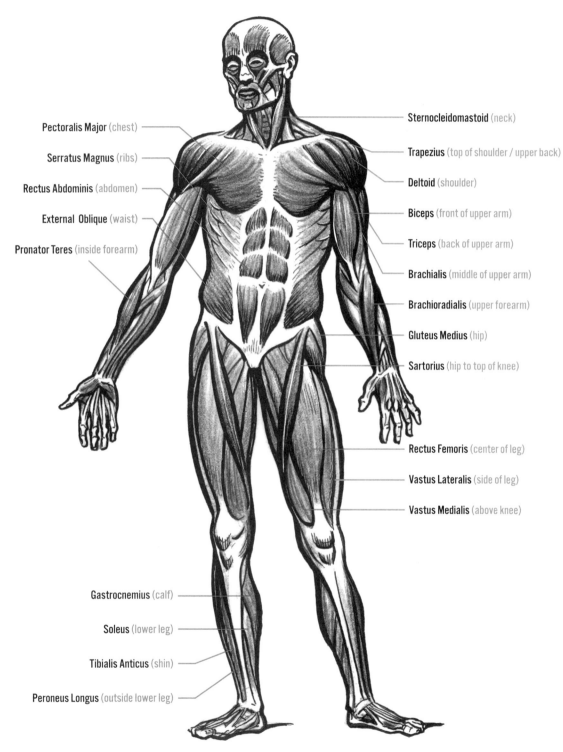

Pectoralis Major (chest)

Serratus Magnus (ribs)

Rectus Abdominis (abdomen)

External Oblique (waist)

Pronator Teres (inside forearm)

Sternocleidomastoid (neck)

Trapezius (top of shoulder / upper back)

Deltoid (shoulder)

Biceps (front of upper arm)

Triceps (back of upper arm)

Brachialis (middle of upper arm)

Brachioradialis (upper forearm)

Gluteus Medius (hip)

Sartorius (hip to top of knee)

Rectus Femoris (center of leg)

Vastus Lateralis (side of leg)

Vastus Medialis (above knee)

Gastrocnemius (calf)

Soleus (lower leg)

Tibialis Anticus (shin)

Peroneus Longus (outside lower leg)

MUSCLES BACK

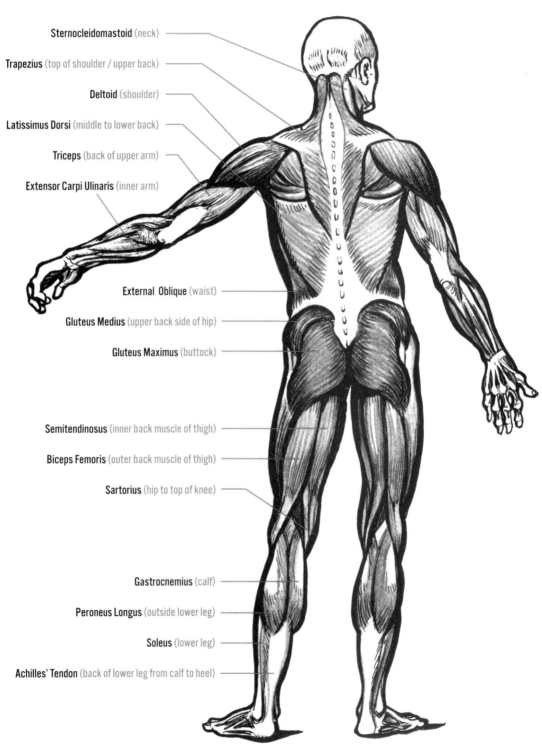

Sternocleidomastoid (neck)

Trapezius (top of shoulder / upper back)

Deltoid (shoulder)

Latissimus Dorsi (middle to lower back)

Triceps (back of upper arm)

Extensor Carpi Ulinaris (inner arm)

External Oblique (waist)

Gluteus Medius (upper back side of hip)

Gluteus Maximus (buttock)

Semitendinosus (inner back muscle of thigh)

Biceps Femoris (outer back muscle of thigh)

Sartorius (hip to top of knee)

Gastrocnemius (calf)

Peroneus Longus (outside lower leg)

Soleus (lower leg)

Achilles' Tendon (back of lower leg from calf to heel)

MUSCLES SIDE

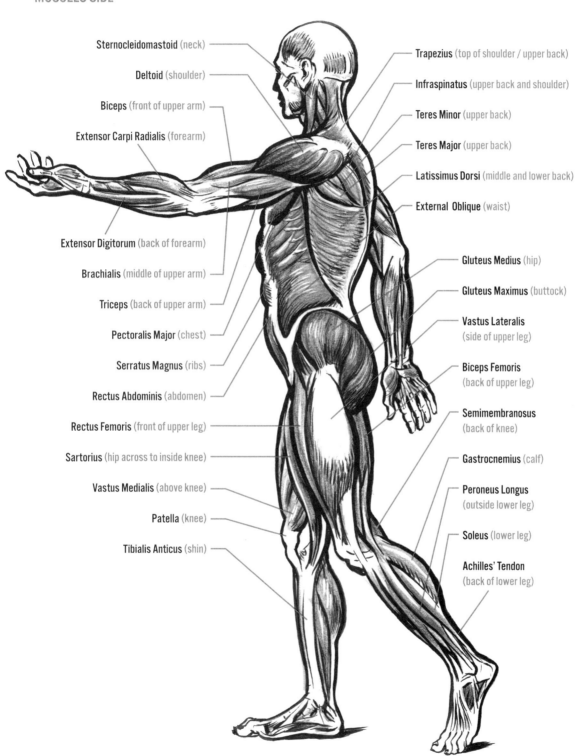

Sternocleidomastoid (neck)

Deltoid (shoulder)

Biceps (front of upper arm)

Extensor Carpi Radialis (forearm)

Extensor Digitorum (back of forearm)

Brachialis (middle of upper arm)

Triceps (back of upper arm)

Pectoralis Major (chest)

Serratus Magnus (ribs)

Rectus Abdominis (abdomen)

Rectus Femoris (front of upper leg)

Sartorius (hip across to inside knee)

Vastus Medialis (above knee)

Patella (knee)

Tibialis Anticus (shin)

Trapezius (top of shoulder / upper back)

Infraspinatus (upper back and shoulder)

Teres Minor (upper back)

Teres Major (upper back)

Latissimus Dorsi (middle and lower back)

External Oblique (waist)

Gluteus Medius (hip)

Gluteus Maximus (buttock)

Vastus Lateralis
(side of upper leg)

Biceps Femoris
(back of upper leg)

Semimembranosus
(back of knee)

Gastrocnemius (calf)

Peroneus Longus
(outside lower leg)

Soleus (lower leg)

Achilles' Tendon
(back of lower leg)

15

Muscles Activate Movement

THE OUTER BODY FRONT

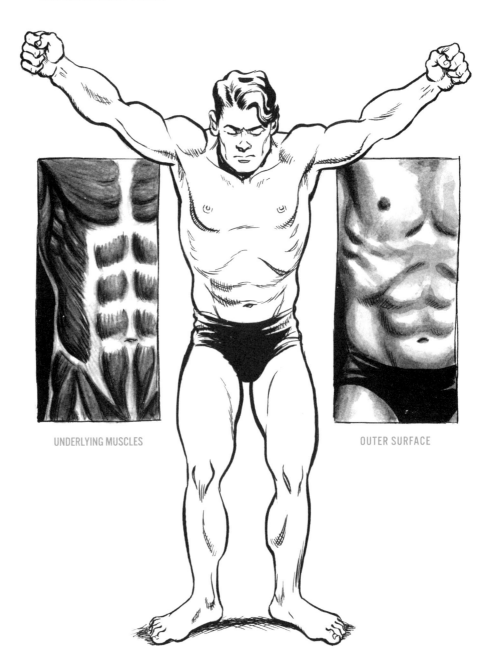

UNDERLYING MUSCLES

OUTER SURFACE

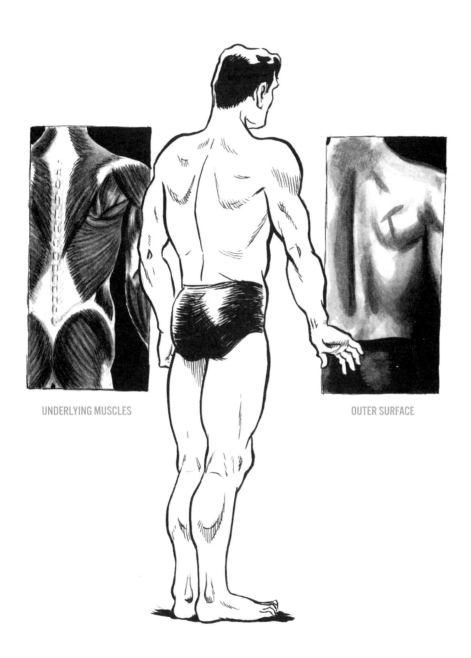

UNDERLYING MUSCLES

OUTER SURFACE

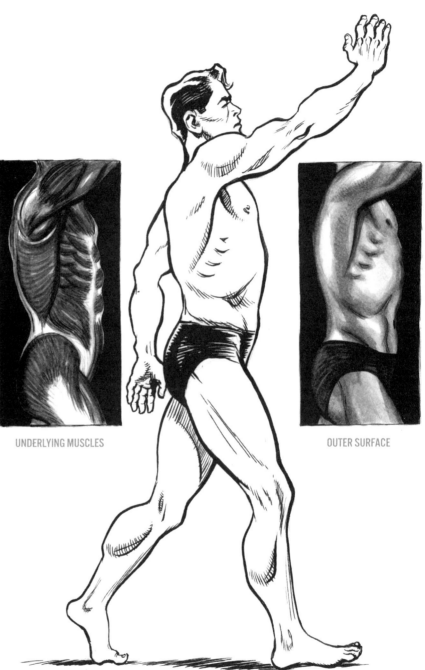

UNDERLYING MUSCLES

OUTER SURFACE

MOBILITY AND LIMITATIONS

The manner of attachment of the body's joints ordains the body's mobility which is activated by muscles. Any change in posture of one part of the body causes an adjustment of bones elsewhere to maintain balance.

Drawing an imaginary plumb line vertically from ear to heel helps to determine if a stationary figure is balanced or not.

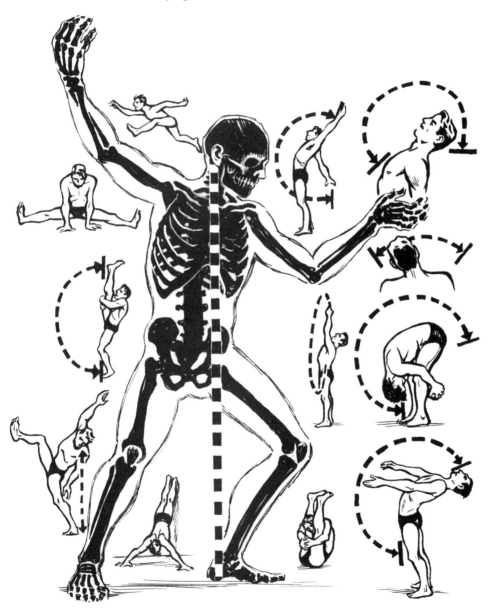

BODY MOVEMENT

While the fluidity of body action responds to the strength and condition of the muscles, the shape, size, weight, age and gender can be modifying factors in the limitation of any kind of movement. Also, between muscle and the skin are layers of fat which can inhibit muscle action in varying degrees.

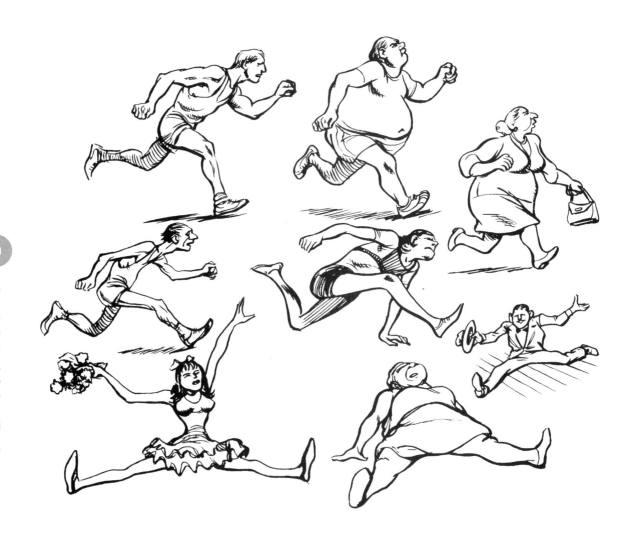

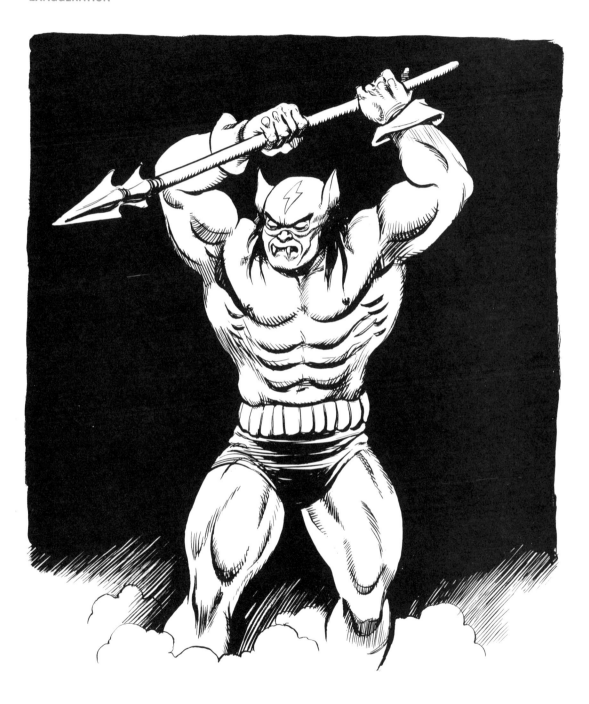

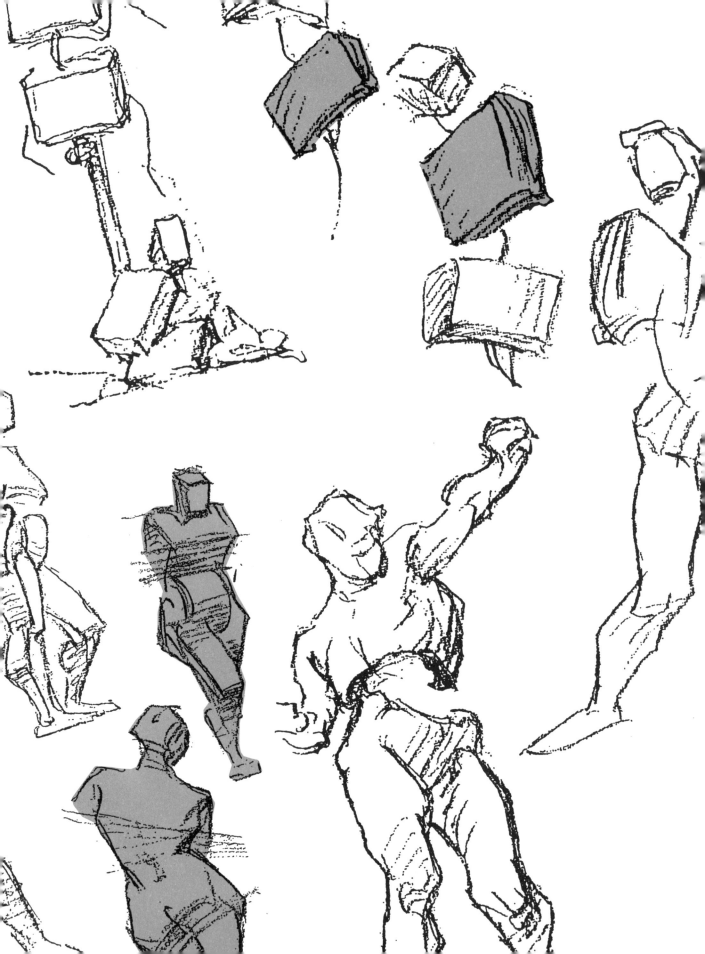

CHAPTER 3

DRAFTSMANSHIP

A familiarity with human anatomy is only a part of what is needed to successfully render people repeatedly in sequence for narration. Confidence in the process of figurative manipulation comes from an understanding of the totality of the body, not only its individual parts. Even now, the best teacher of this is George B. Bridgeman, a muralist who taught anatomy at the Art Students League in New York from the 1910s through the 1930s. His unique concept of reducing the body's architecture into connected two-dimensional blocks enables the draftsman to easily create postures. Upon this foundation, detail of individual shape or clothing can be realistically applied while maintaining the accuracy of perspective. In the following pages are a sampling of his demonstrations. Norman Rockwell, another student of Bridgeman's, reminisced about the great teacher in *Norman Rockwell: My Adventures as an Illustrator*:

Mr. Bridgeman kept a skeleton in his locker at the League. When he wanted to explain some difficult point of anatomy he'd haul it out and, holding it up by a brass ring in the skull, point out the bones he was describing and work them back and forth to demonstrate his point. "See that," he'd say, folding the wrist back toward the forearm, "This structure here does it," and he'd go on to explain how the bones and muscles of the wrist worked. "It's a damned wonderful thing," he'd say. "Take the pelvis. Or the rib cage. Every cruddy little bone and muscle working together. How many muscles d'you think it takes to move your little finger? Eleven . . . ELEVEN." Then, falling silent, he'd rotate the chest of the skeleton and move the arms about, shaking his head. "It's a damned wonderful thing," he'd say.

> **CONFIDENCE IN THE PROCESS OF FIGURATIVE MANIPULATION COMES FROM AN UNDERSTANDING OF THE TOTALITY OF THE BODY, NOT ONLY ITS INDIVIDUAL PARTS.**

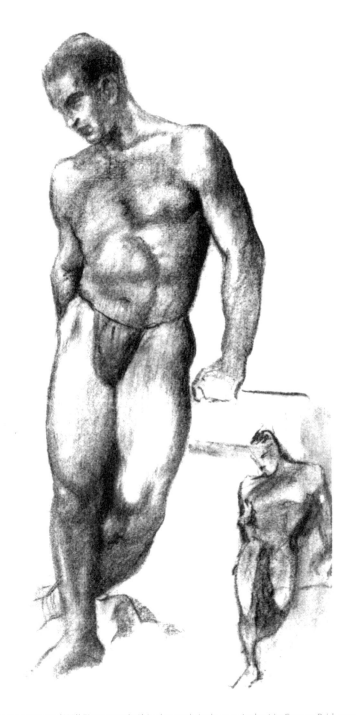

ABOVE: In 1935 a teenaged Will Eisner made this charcoal study as a student in George Bridgeman's Art Students League figure drawing class. Bridgeman himself may have contributed the smaller figure in the corner as an example to young Eisner as to how to quickly establish a sense of dimension to a human figure by blocking out the shadows as abstract shapes, as the excerpts from his classic book on drawing indicate.

After he had been all around the class Mr. Bridgeman would stand in the corner behind us and make general comments on drawing, on the construction of a certain organ, on shading. "Anatomy," he'd say, "muscles. You can't draw a leg if you don't know what makes it move backward from the knee instead of forward. The body isn't a damned hollow drum covered with skin. The bones, muscles give the body its shape, determines how it moves. Why, the whole bunch of you act like quack surgeons who'll cut a hole in the chest to get at the tonsils. You've got to know what's underneath the skin of the belly to draw it. Now look here . . ." And digging a nubbin of soft red chalk from his shirt pocket, he'd walk to the model stand and draw the muscles of

"THE BONES, MUSCLES GIVE THE BODY ITS SHAPE, DETERMINES HOW IT MOVES. WHY, THE WHOLE BUNCH OF YOU ACT LIKE QUACK SURGEONS WHO'LL CUT A HOLE IN THE CHEST TO GET AT THE TONSILS."

the stomach and the line of the rib cage right on the model with his chalk. (The models disliked this. They used to say it gave them a queasy, squirmy sort of feeling to have their muscles marked on their skin in soft red chalk. And then there was no place at the League where they could wash properly and they'd have to go home with their muscles outlined in red.) "There," Mr. Bridgeman would say when he'd finished. "When you can do that for the whole body you'll be able to draw it."

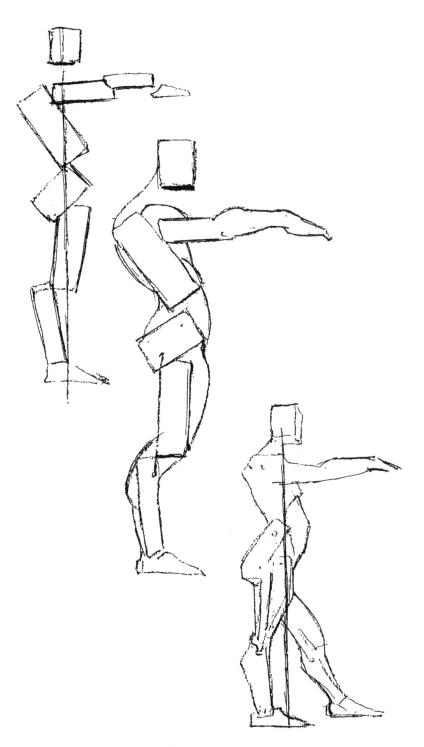

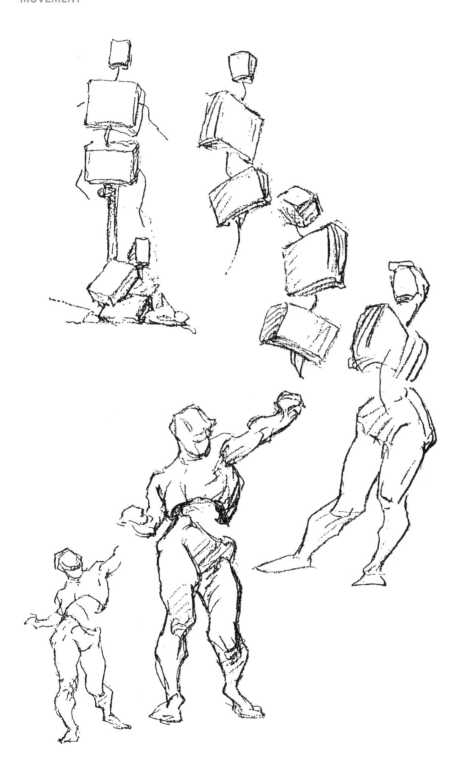

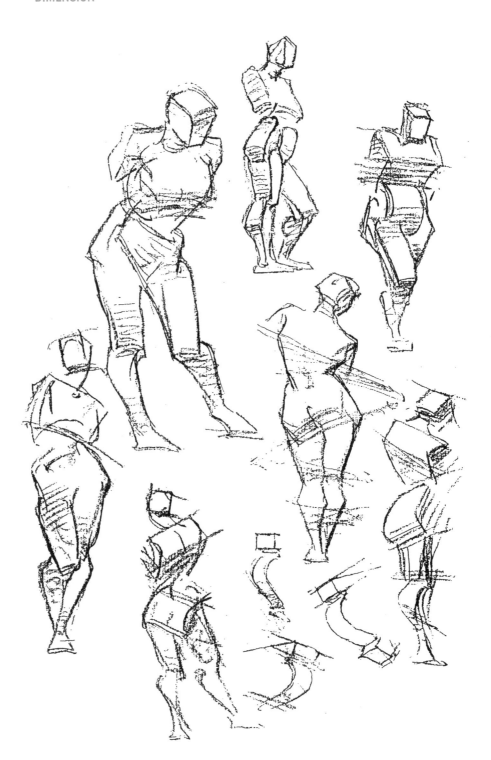

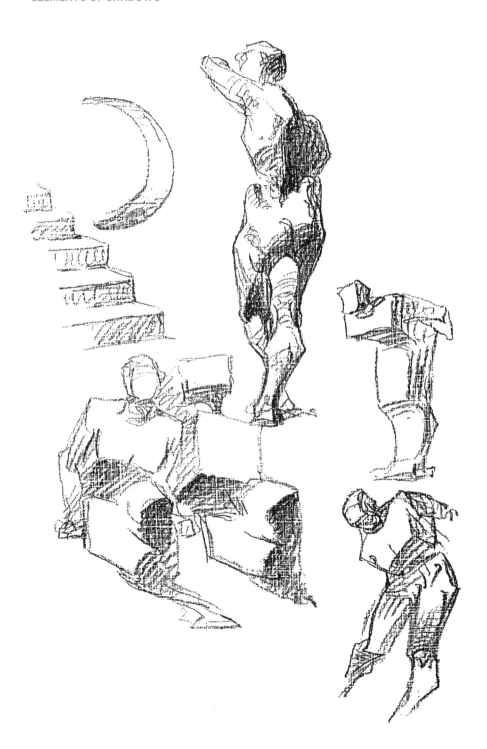

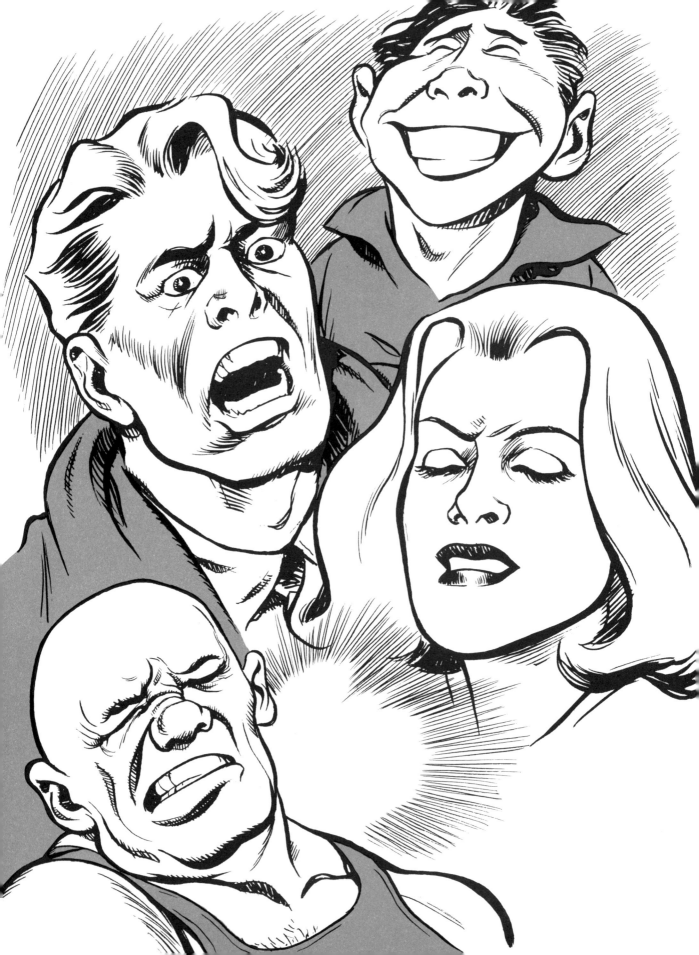

CHAPTER 4

THE HEAD

The skull of the human head contains the eyes, ears, nose and mouth; the organs that mostly provide information to the brain housed in the hollow cranium. Aside from the additional intelligence provided by the sensory system throughout the body, it is the structure of these features which provides the individual characteristics that form an easy to read display of emotion and personal identity.

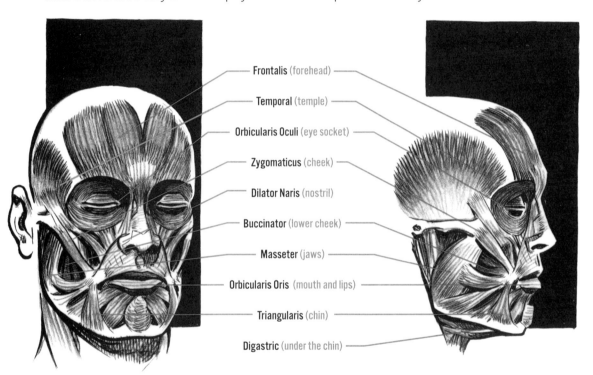

Frontalis (forehead)

Temporal (temple)

Orbicularis Oculi (eye socket)

Zygomaticus (cheek)

Dilator Naris (nostril)

Buccinator (lower cheek)

Masseter (jaws)

Orbicularis Oris (mouth and lips)

Triangularis (chin)

Digastric (under the chin)

How the muscles on the face are attached to each other enables them to display the familiar signals of an emotion.

FACIAL EXPRESSIVENESS

Emotions in the MIND trigger the BRAIN to activate responding MUSCLES in the face and neck.

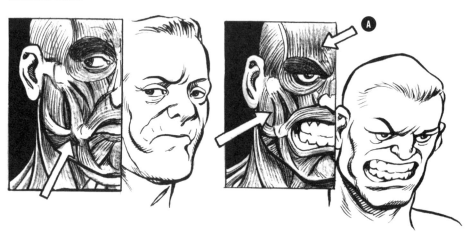

A sneer: The cheek muscle contracts and pulls the upper lip.

Clenched teeth aggression: The cheek muscles contract on both sides of the face to pull open the mouth in a snarl. **A** The brow and neck muscles contract.

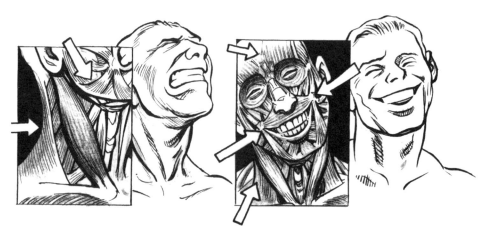

Torment or extreme pain: The head is pulled back as the cheek muscles of the face and the muscles in the back of the neck contract.

Hilarity: The cheek muscles on both sides of the face contract, drawing the corners of the mouth up in a wide grin while the muscles under the forehead expand to relax the eye area. One major neck muscle contracts, stretching the muscles on the opposite side and allowing the head to cock or cant.

THE BRAIN

For the artist concerned with portraying human action in the process of narration, it is useful to be familiar with the brain's function. This very complex organ commands the intricate system of cells, synapses and circuitry that orchestrates the action of postures, gestures, grimaces and sounds which humans employ to display emotion, execute the action required by reason and respond as a reflex to injury.

1 Center for the movement of legs and feet.

2 3 4 Center for complex movements and coordination of arms and legs.

5 Forward action and extension of arms and legs.

6 Repeated bending of hands and rotation of forearm.

7 8 Elevation and depression of the angle of the mouth.

9 10 Movement of the lips and tongue.

11 Retraction of the angle of the mouth.

12 Movement of the eyes.

13 Vision.

14 Hearing.

a b c d Movements of the wrists and fingers.

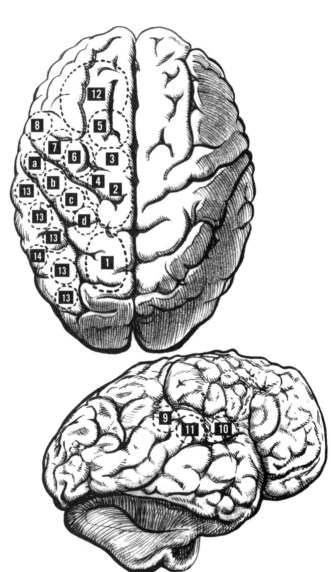

CHAPTER 5

ALL LIVING THINGS WANT TO SURVIVE

A fundamental assumption in the depiction of human conduct is that its action is connected with a will to live. Human anatomical structure is designed to abet survival.

For the purpose of this consideration we step aside from the philosophical and scientific debate over the seat of reason and proceed on the premise that the mind and the brain are partners in human conduct.

A realistic basis for the portrayal of human action in graphic narration is as follows: the MIND originates a strategy and initiates the action by alerting the BRAIN, which engineers the transmission of signals. The process of movement is the result of a store of experience collected over time, using the sense organs: eyes, nose, mouth, touch and the network of nerves and sensors throughout the BODY.

The postures and gestures of human actions are actually a mechanical result of the mind and the brain's processing external stimuli like pain, joy or threat.

HUMAN ACTIONS

Human actions are divided into two major groups: reflex and emotional, which apply to the moment to moment spontaneity of daily living. A third category is intelligent action which is an extension of both groups. This refers to human action in a learned context where the movement is repeatable such as with jobs requiring physical labor, sports, and theatrical performances.

LEFT: EMOTIONAL ACTION—A voluntary action rooted in the desire to express a strong feeling or satisfy a biological need. This kind of action is demonstrated physically in a larger variety of ways than involuntary reflexive action.

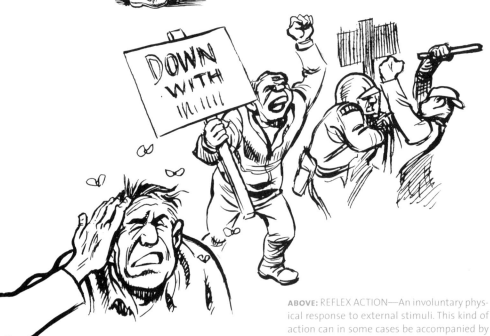

ABOVE: REFLEX ACTION—An involuntary physical response to external stimuli. This kind of action can in some cases be accompanied by a responsive emotional display.

EMOTIONAL ACTION When the MIND reasons or determines that a response to a situation is necessary, it orders the BRAIN to engineer an appropriate action. Likewise, when the MIND wishes to express relief from danger or delight in winning, it alerts the BRAIN to express the accompanying emotion.

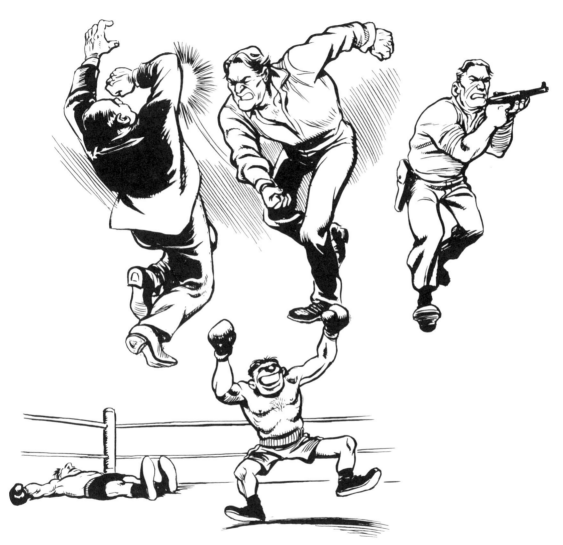

REFLEX ACTION The BRAIN's unplanned mechanical reaction to external stimuli like pain, joy, injury or a surprise movement.

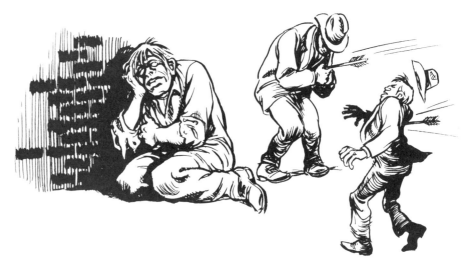

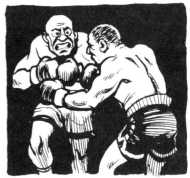

ABOVE: Often reflex actions accompany defensive actions.

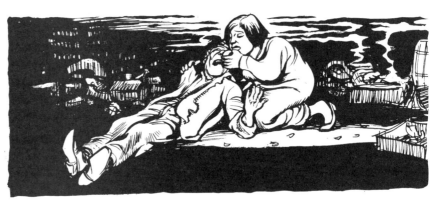

ABOVE: An emotional action can occur as a result of a reflex action.

INTELLIGENT ACTION An estimate of danger is sparked in the MIND, determining action. Depending on the history of experience and stored information in the BRAIN, the BODY is moved out of the predicted path of an oncoming object. An assessment of danger has been made by the MIND and, contriving a solution, it orders the BRAIN to mobilize the BODY for the quickest route to safety.

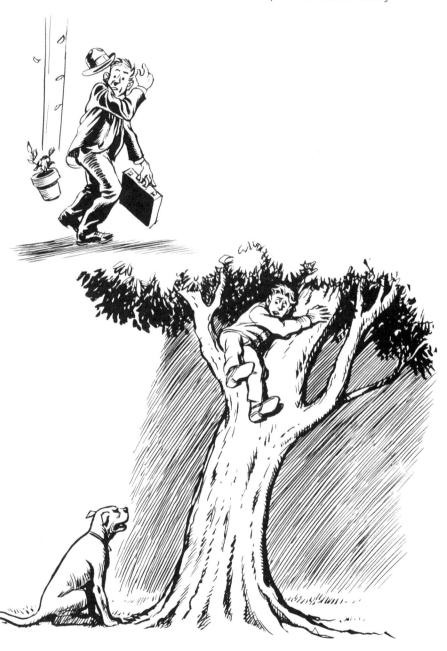

ATHLETIC COMPETITION

ABOVE: A sport is a physical game with rules. While not a life-threatening situation, to play a sport well demands intelligent action out of reflexes that combine speed, endurance and strategy, within time limits.

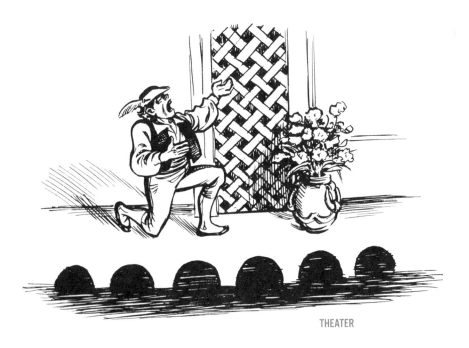

THEATER

ABOVE: Actors use intelligent action such as pantomime to express emotions that will communicate humor or pathos to entertain a paying audience.

THE MIND, THE BRAIN AND THE BODY (AN EXAMPLE)

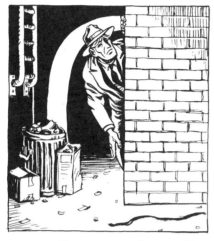

PANEL ONE: The BRAIN recognizes something that surprises it and the reaction instantly freezes the BODY in motion.

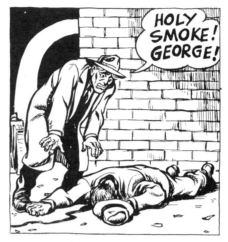

PANEL TWO: The MIND reacts with emotions of horror and disbelief while the BODY moves closer for more information.

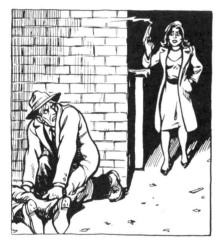

PANEL THREE: The BRAIN surveys the scene recording all the facts presented to it. A second sudden surprise occurs. The BODY turns and again freezes to process this new information.

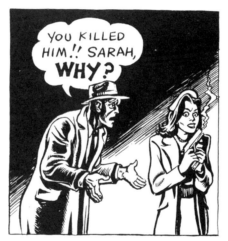

PANEL FOUR: The MIND reasons and draws a conclusion based on the evidence presented and demands further information. The BRAIN tells the BODY to move into a pose of confrontation with a gesture that evokes persuasion.

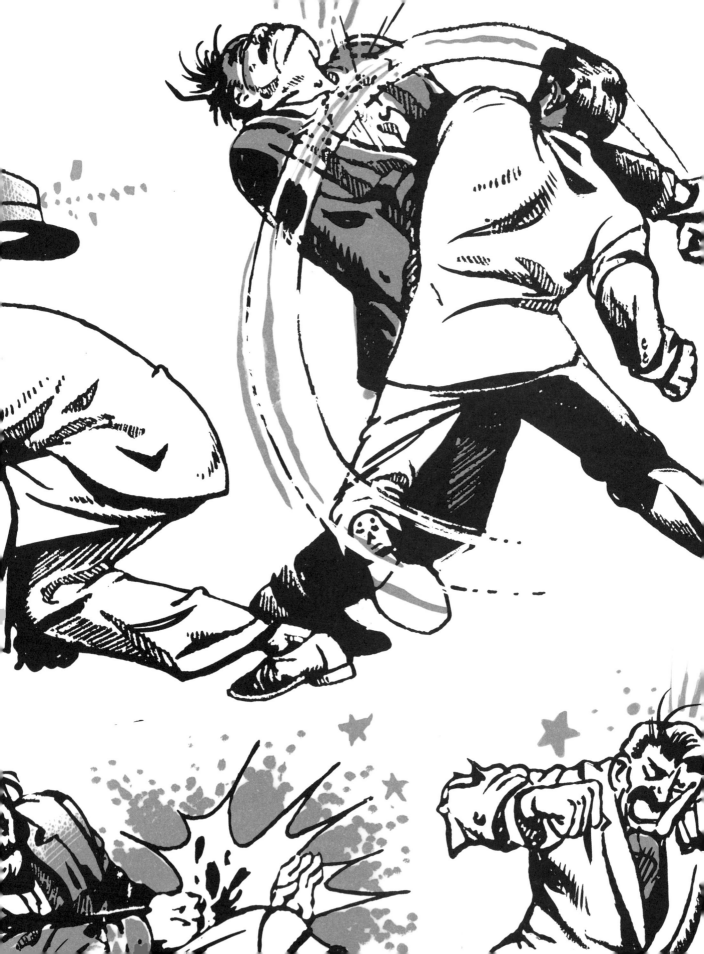

CHAPTER 6
THE LANGUAGE OF POSTURE AND GESTURE

In sequential art for comics, panel borders, dialogue balloons and caption boxes are reading guides for the logical progression of the story. While I believe this to be an elementary structure in the creation of graphic literature, it remains uncertain which is read first, image or text. Do we scan the drawing and read the text or read the text and scan the drawing? Perhaps this depends on which of the two groups an individual's learned habit of processing information falls. I maintain that posture or depicted action precedes dialogue in the reading process. This primacy requires an artist to master body action to render humans in movement. It seems to me reasonable to assume that the brain generates a vocal response (speech) in support of a reaction or an emotion that may accompany a happening.

NOTE: Will Eisner's interest in visual storytelling was challenged by the early comic book page format and he, on occasion, would playfully experiment with readability and graphic presentation. Here for comparison are two Eisner stories. The first, titled "Killer McNobby," is an eight-page *Spirit* section originally published on June 1, 1941, one year after Eisner had created the feature. He was twenty-four years old. To tell this particular *Spirit* adventure Eisner decided to do away with all panel borders (except the *Spirit* splash page), dialogue balloons, text captions, and sound effects, and then illustrate a fanciful limerick about a villain named Killer McNobby (Joseph Stalin) and what happened when he and the Spirit crossed paths. Eisner used all the tricks of the movies: broad gestures, violent action, crowd reactions, aerial perspectives and emotive close-ups. He even exaggerated the ongoing battle with a comical chorus to further fragment the images and text but also to use the humor as a counterpoint, a device to defuse the brutality of the brawl until the Spirit delivers the knockout punch. Naturally, Eisner was criticized by the gentle Sunday morning readership of his client newspapers for this bombastic low-brow entertainment. But it pleased him all the same, because it proved he was connecting with the vast unseen audience. Now look at "Hard Duty" (a true story written and drawn by Eisner fifty-nine years later, in 2000, when he was eight-three years old), which appeared in his war memoir *Last Day in Vietnam*. Again the artist has done away with the architecture for page design to allow for a melting together of image and voice in what is essentially a short character study. For three pages in a row Eisner overlaps the gestures of a strong figure with a rough and exaggerated portrait close-up of a soldier in Korea crudely describing himself. Then for the

final page, another character describes this same person in the totally opposite way for the surprise punch line. These two examples of Eisner's art from opposite ends of his career demonstrate his belief, artistically and philosophically, in the hierarchy of posture and gesture visuals over the text.

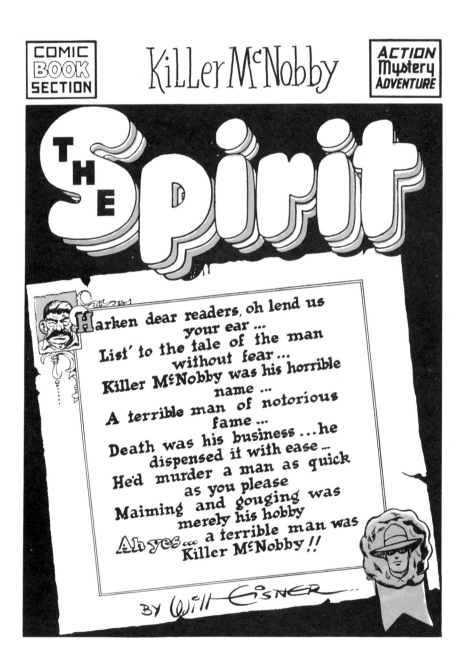

Now.. starting small at this infamous call , he
decided to steal for a living ...
His victim, the dope, swung at him with a rope
and was killed without any misgiving..

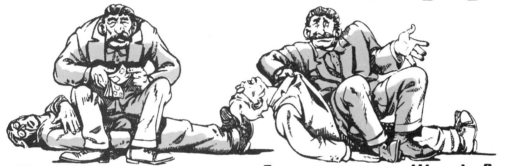

Yes.. here's a career for a man without fear
thought he as he counted the loot...
Dead people don't peep and with overhead cheap,
he could soon make a name to boot ...

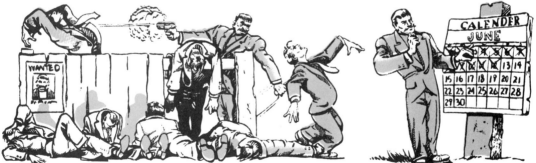

So.. with gun full of lead and such thoughts
in his head, he started to go on his way...
He would stab some poor men and steal now
and then, but committed one murder each day ...

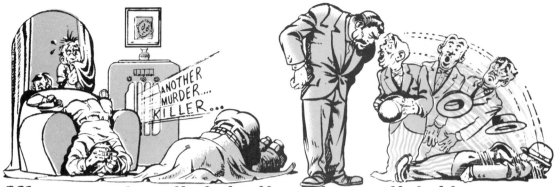

His name it spelled death and we all held our
breath when his deeds were told o'er the air...
He looked so darned tough that his face was enough
to kill a man right then and there...

But in North Central City, not changing our ditty,
lived The Spirit but deep underground...
A man whose great name was as equal in fame in
completely the other way 'round...

The Spirit, you see, as it happens to be, is a smasher
of rackets and evil...
He decided 'twas time that he halted all this crime
and arrested this social boll-weevil...

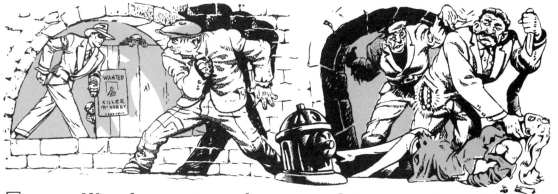

So.. without any gun.. he never lugs one.. he set out
to search thru the slums ...
The news of his coming.. he never went slumming..
was spread by fast spies on the run ...

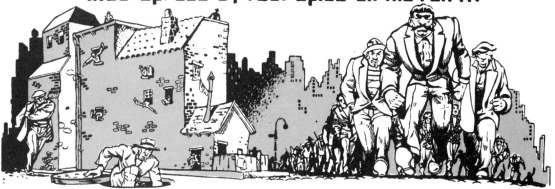

Now.. the underworld knew 'twas a storm in the
brew.. and gathered to cheer for their champ ...
When The Spirit appeared, not a gangster was near,
not even the lowliest tramp ...

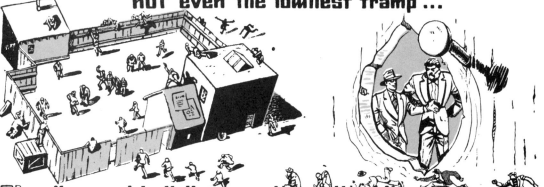

Oh.. they met in Kelly's yard and the killer's eyes
were hard as The Spirit calmly bowed and slowly said..
You're at the end of your rope.. you'll confess I hope,
for, if not, I'll beat you till you're all but dead ...

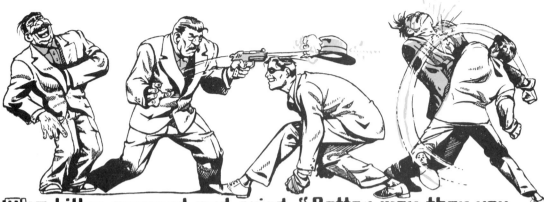

The killer sneered and cried, "Better men than you
have tried", as he promptly drew a gun and tried to shoot..
The Spirit stepped in low, swung a careful blow and
smashed M°Nobby squarely in the snoot ...

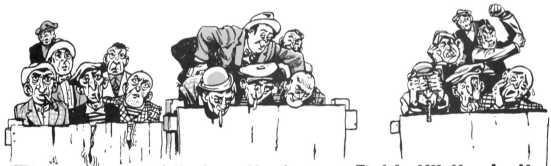

The crowd held its breath, 'twas a fight till the death..
for the killer quickly matched him punch for punch..
The Spirit hit the floor, but as yet he wasn't sore, for he
countered with a punch that made him crunch...

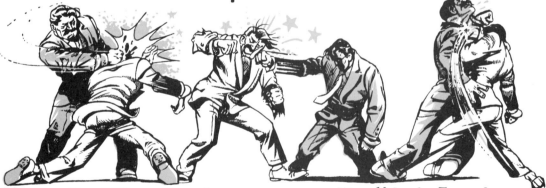

Now.. the killer clearly saw a man like this before, he
never fought or yet encountered ...
For each time he dropped his guard, The Spirit swung ...
but hard !... and followed thru before M°Nobby countered !!

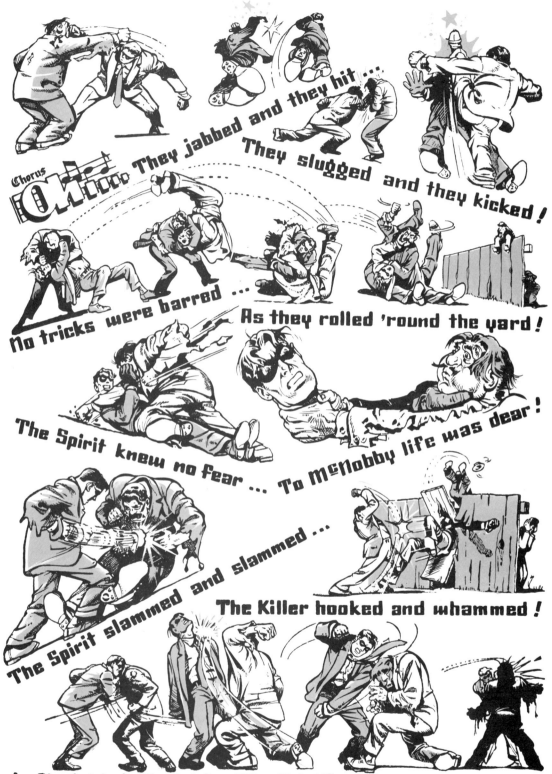

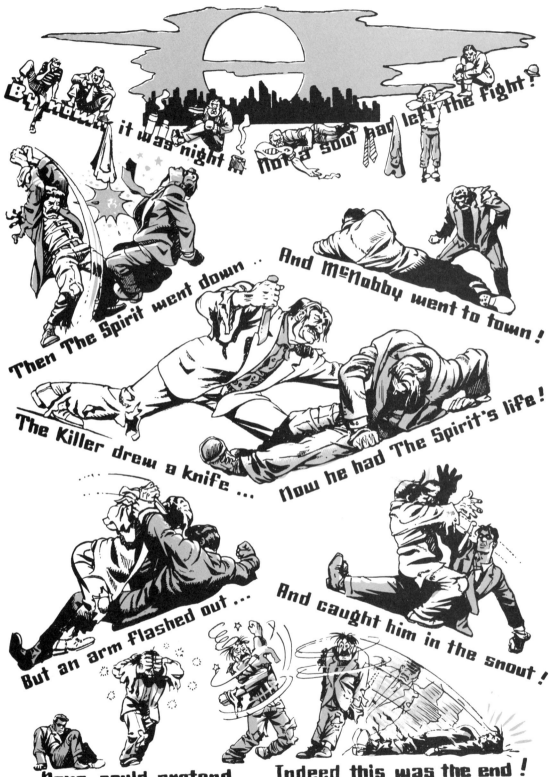

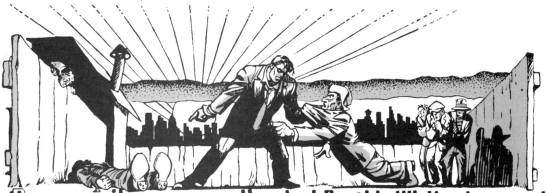

By now... it was morn..they had fought till the dawn and
The Spirit slowly turned to the crowd ...
Their champ he was done, they squealed everyone as
before The Spirit, Killer bent and cowed !

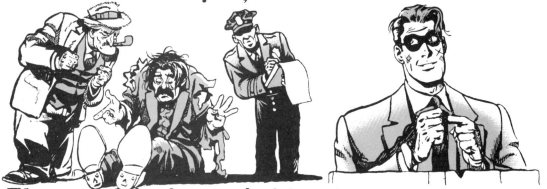

Oh yes.. their stories jibed for when Dolan arrived,
McNobby's guilt was clear to everyone ...
Why even McNobby, when pressed, readily confessed
while The Spirit cooly sighed,"The case is done!"

Then... The Spirit headed north as they lugged McNobby
off, and the morning sun 'rose brilliant full and clear ...
And so... over soup grown cold it is very often told ..
alas ... The Story of the man who had no fear!!

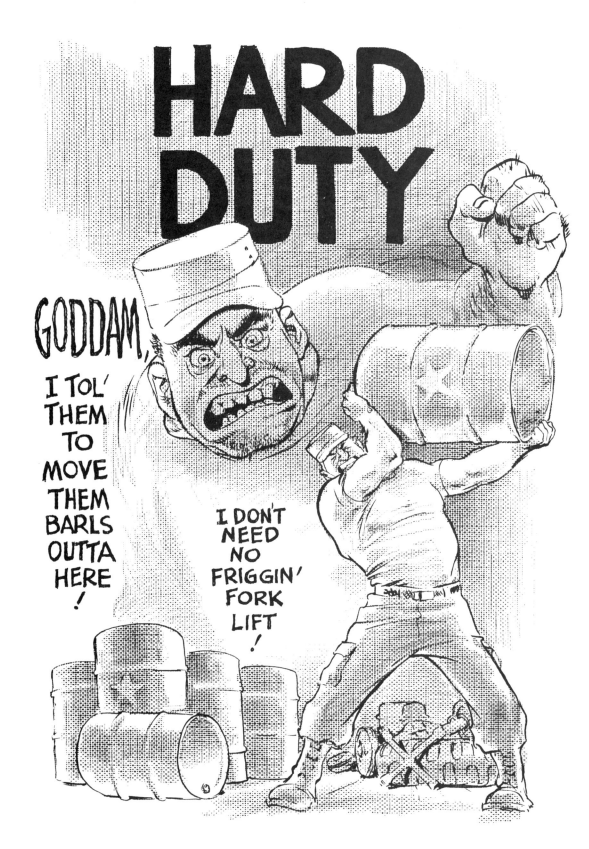

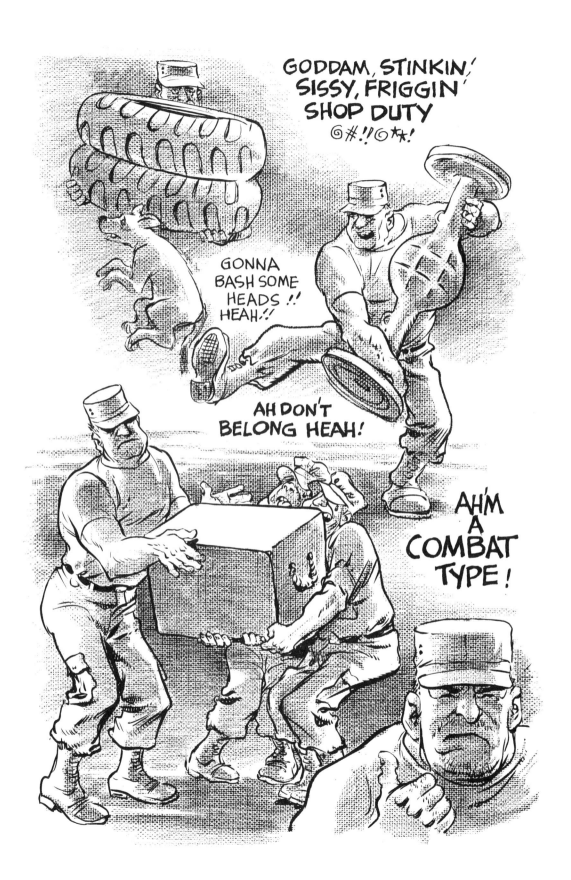

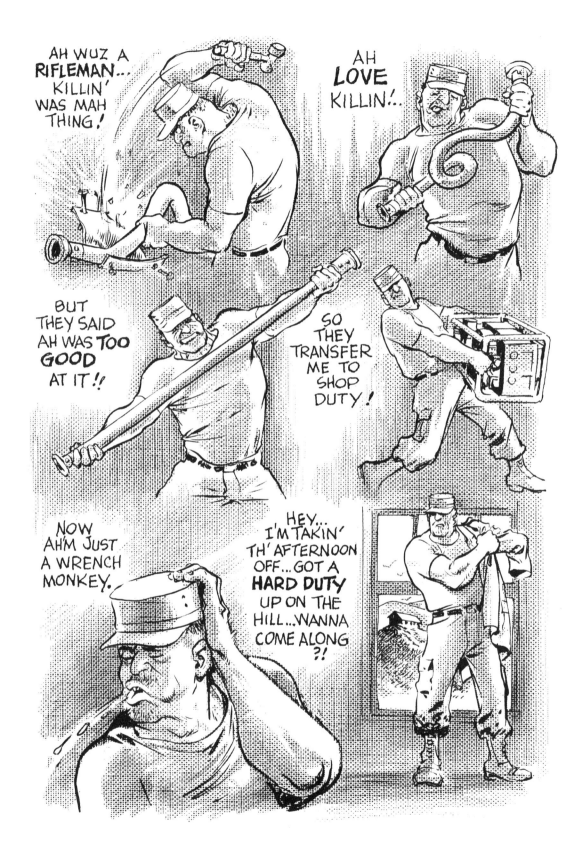

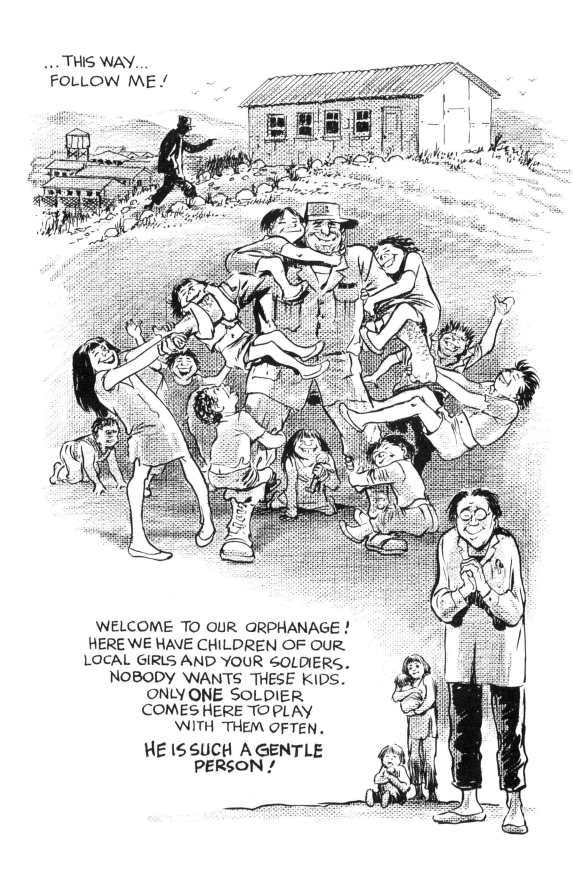

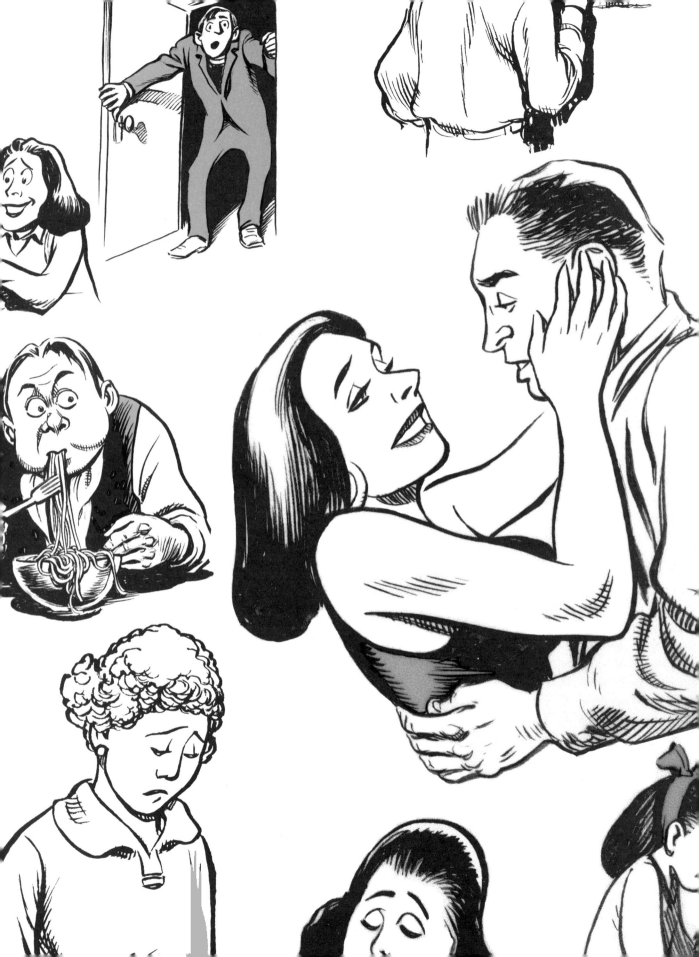

CHAPTER 7

HUMAN EMOTION

All physical action is accompanied by emotion. Grief, elation, joy, envy, shame, relief, anger, rage and happiness are human feelings that can be demonstrated by universal postures and gestures. The draftsman should keep in mind that an emotional display is not necessarily confined to the face. The muscular responses ordered by the brain involve the entire body in concert and are influenced by such diverse elements as the environment or external setting as well as the age, sex and the anatomy of the actor. The personality, physique and even the occupation of the actor are also part of the chemistry of a character that determines the range of expression possible in a given situation.

ABOVE: The Super's courage is fortified by alcohol in *A Contract With God*. Such a close-up display of facial expressions aids the reader in imagining the entire physicality as well as the personality of a character.

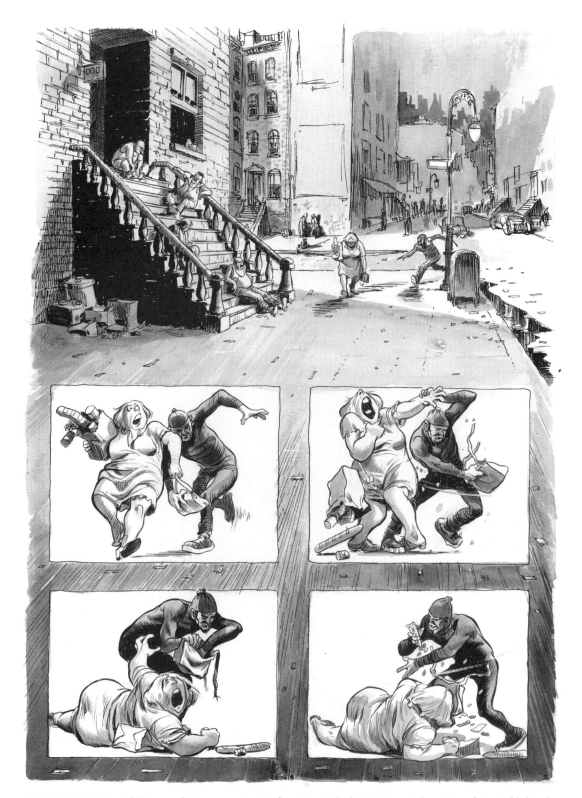

ABOVE AND OPPOSITE: In "Witnesses," a two-page vignette from *New York: The Big City*, note how Eisner first establishes the location of a crime and then isolates the theft and escape by removing the background so that the reader can easily read the gestures and postures of the thief and his victim while the people on the stoop remain part of the steps. By not having

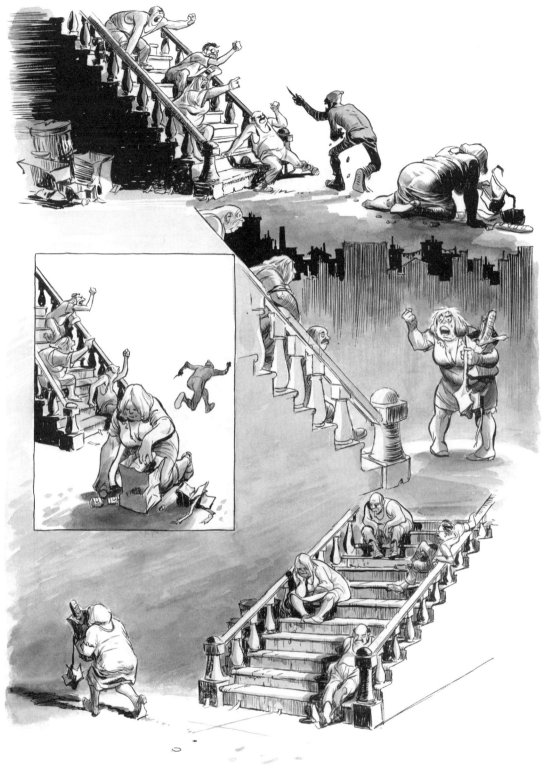

any dialogue or sound effects Eisner forces his readers to be silent witnesses themselves, seeing everything but keeping their distance and not getting involved.

HATE

Hatred is one emotional prelude to physical action. The body's posture is changed to fit the kind of action intended. The brain orders the muscles to prepare the body for the action. On the face, jaw muscles are tightened, teeth are clamped, and the neck stiffened. The fists are clenched. If hatred is suppressed, the body accommodates by adjusting its posture to hide feeling and frustration. Human anatomy is engineered to not only protect the body but to respond to internal emotions.

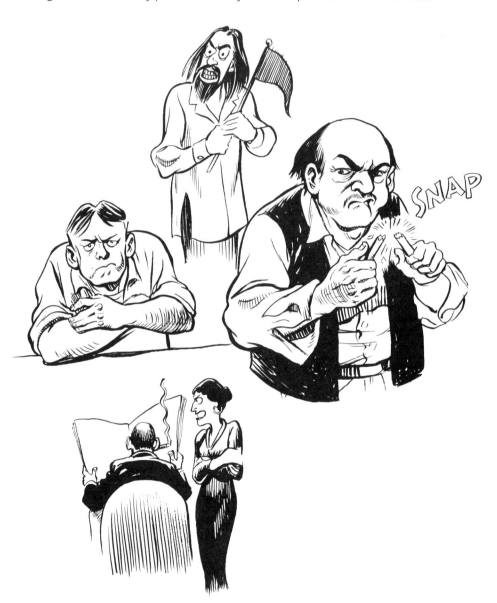

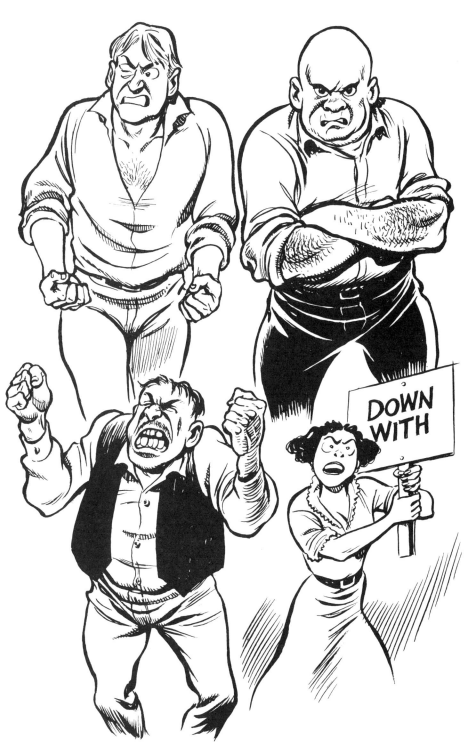

ABOVE: The tension in these figures conveys hatred and explosive anger.

SHAME

This emotion is triggered by memory of something the person is sorry for or embarrassed by. Posture depends on the cause of the shame. If the cause happened within minutes before, then the mind orders the muscles to clench teeth, close fists, hug arms to the body, and pull the spine upright with neck muscles rigid in order to deal with disapproval. If the cause of the shame occurred in the past, the mind will assume a denying or dismissive attitude to suppress its memory probably in order to deal with the pain of guilt and disapproval by others.

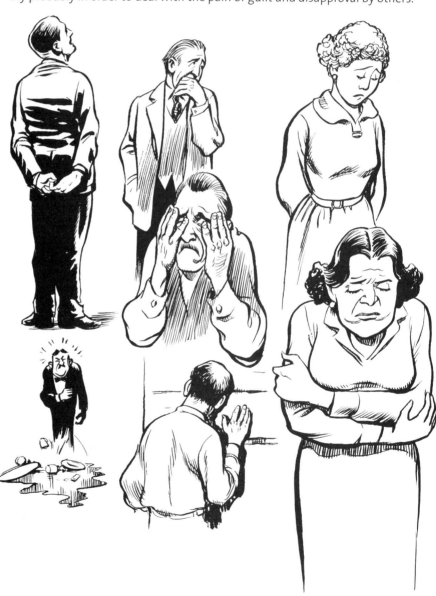

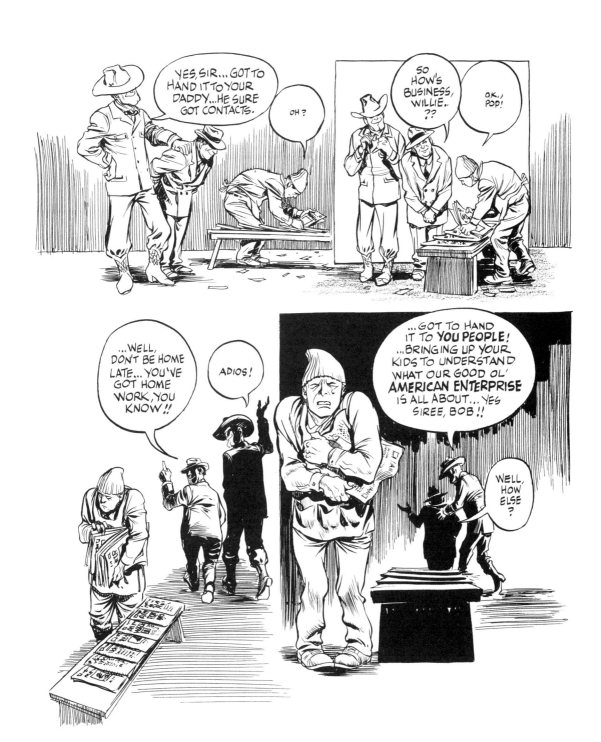

ABOVE: More Eisner personal history: young Willie is ashamed seeing his out-of-work father acting like he is a successful entrepreneur in *To the Heart of the Storm*.

LOVE

The emotion of love is often portrayed by a voluntary posture rather than a reflexive one. The most expressive gesture is one of tenderness and concern for someone's condition. Muscles relax the body and the movable bones are used to manipulate shoulders and arms to make gentle gestures to communicate this feeling.

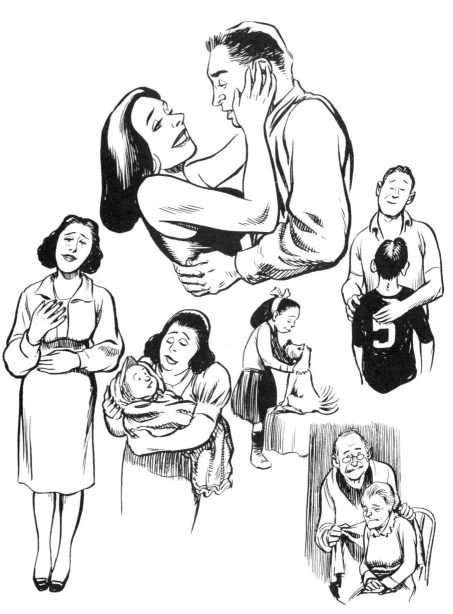

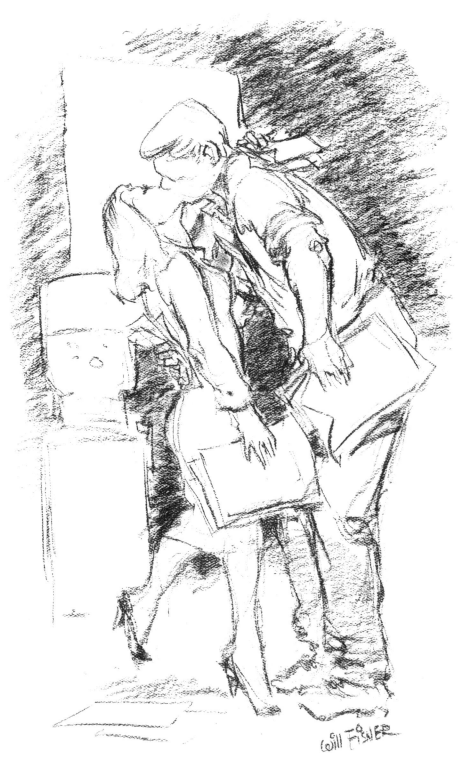

ABOVE: The grasping of office papers dramatizes the spontaneity of the couple's romantic moment.

SURPRISE

The human body responds to an unforeseen event as it would to the anticipation of a physical threat. The muscles tend to tighten around the skeleton. The posture is upright and rigid, emulating an interruption in the body's previously intended action. A portrayal of surprise must take into account the activity in which the body was engaged because the manner of disengagement will describe the nature of the surprise.

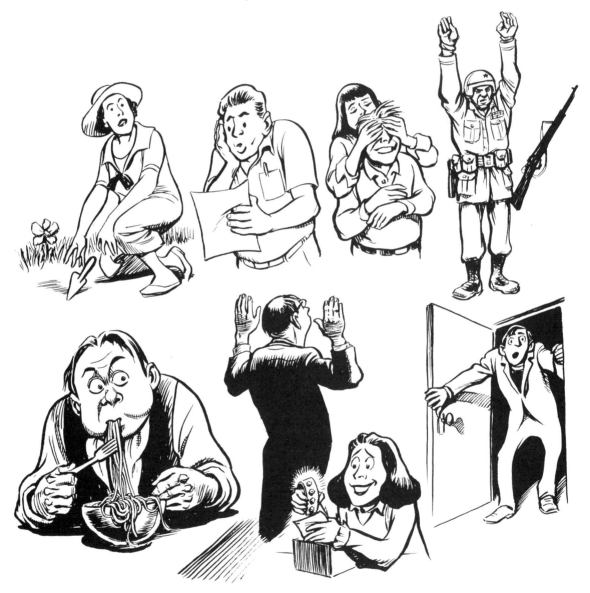

ABOVE: The surprise of sudden rejection in "The Power," from *Invisible People*.

ANGER

Because anger can be followed by frustration, depression or physical acting out, muscles will contract and alter body posture to control and disguise the emotion, or in the case of a physical reaction, the brain generates the chemistry that creates violent movement. In stories where the plot centers on vengeance or pursuit, the solution to the threat is usually a violent physical one. Here the classic display of familiar postures of human anatomy in action is essential.

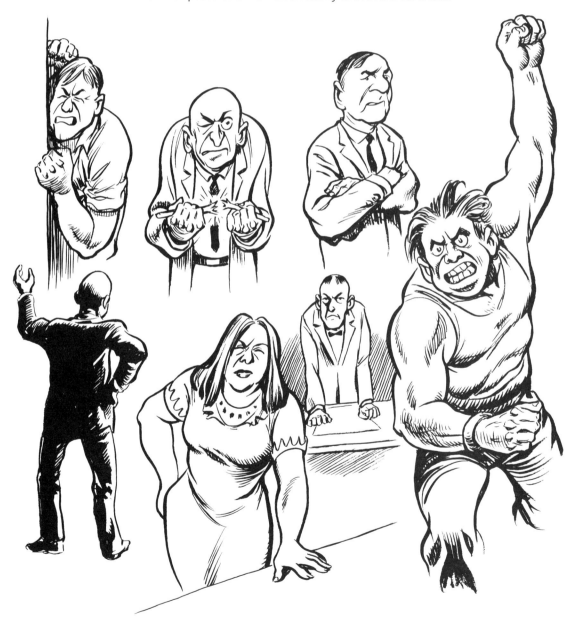

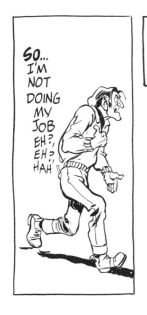
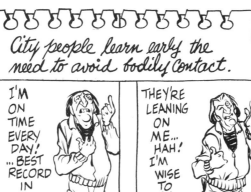
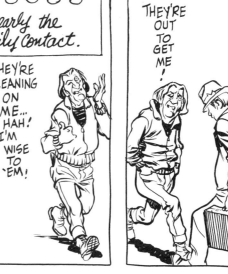
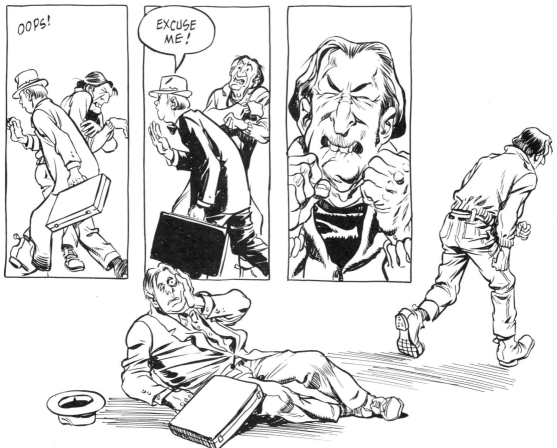

ABOVE: The collision course of two unlikely combatants is observed in *City People Notebook*.

FEAR

A reaction to the imminence of bodily harm causes a sudden alteration of posture. The body is positioned for defense, flight, resistance, surrender or to intercept a blow. Physique (fat or thin) can influence posture by inhibiting or enabling the fluidity of movement. While an athletic body will poise for a fight, a weak one will shrink or seek the nearest shelter. Under threat of disappointment or anticipation

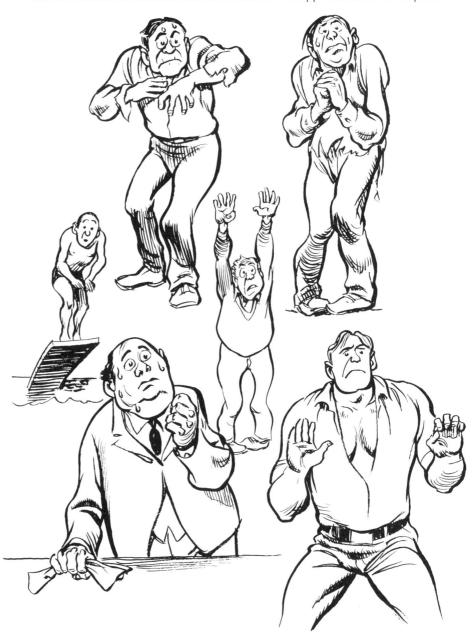

of bad news, the muscles tighten and the body becomes rigid. The face exhibits various reactions to a physical threat. Eyes widen in an animalistic effort to see the source of the danger, or other enemies, and find an avenue of escape. In emotional threat, the eyes narrow or close to shut out the bad news.

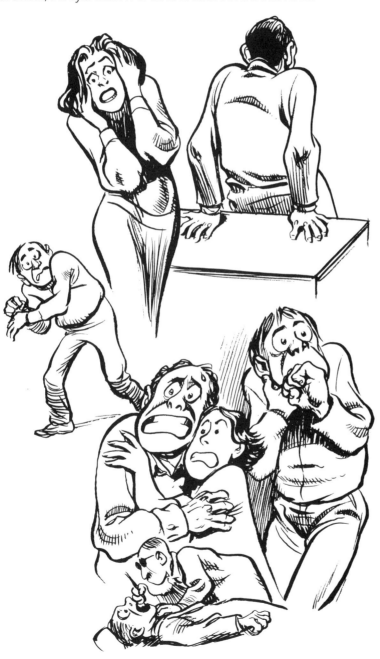

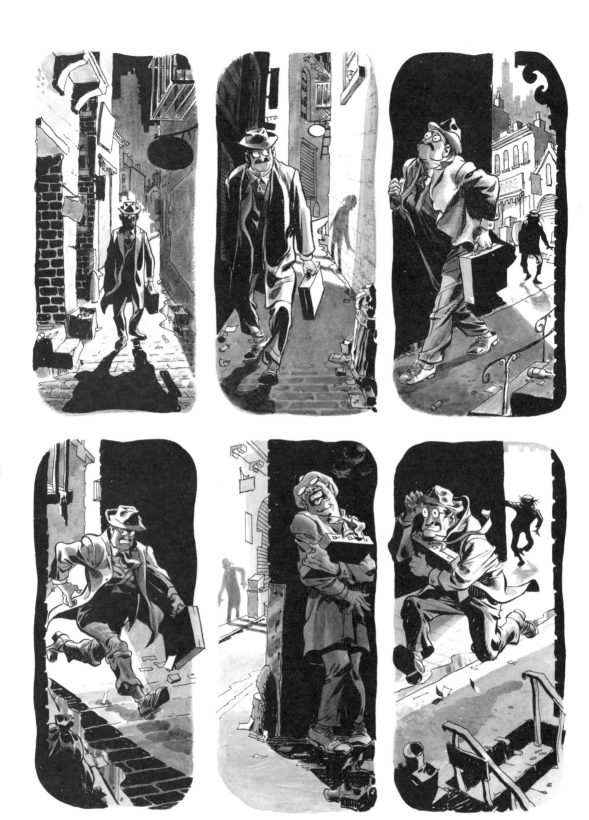

ABOVE: The running gauntlet of fear, panic, and relief that animates a man walking home at night in an urban jungle as depicted in "Lamppost," from *New York: The Big City*.

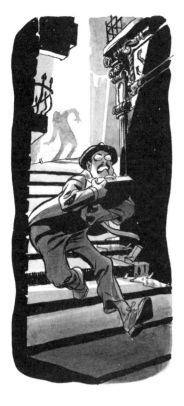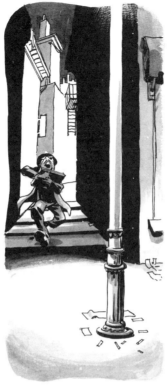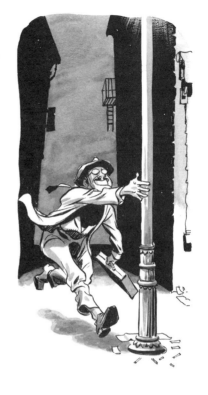

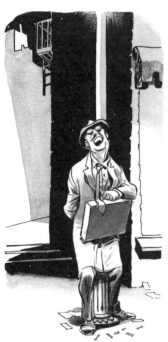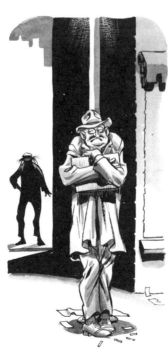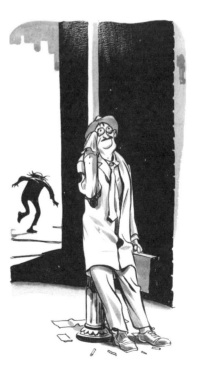

JOY

Because the reasons for joy are so varied, the depiction of that emotion must be done with concern for its cause and the characteristics of the person involved. Common causes for joy are: victory, a successful endeavor, extreme physical relief, a threat that did not happen, or a reaction to good news. Muscles in the face relax or activate a grin, and relaxed shoulders loosen gestures and body movement, for there is no reason to be defensive. The postures display a feeling of safety, an expression of victory, unsuppressed satisfaction, accomplishment or an acquisition.

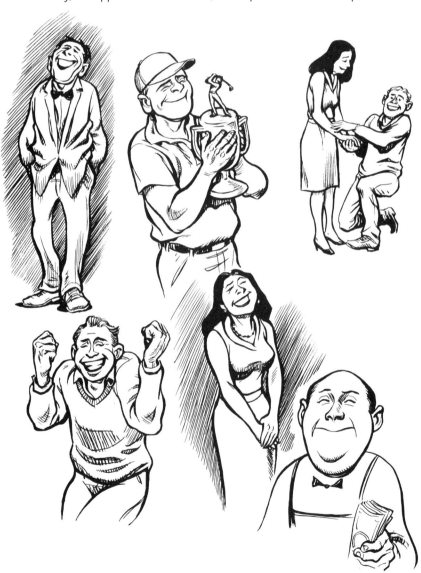

CASTING CALL

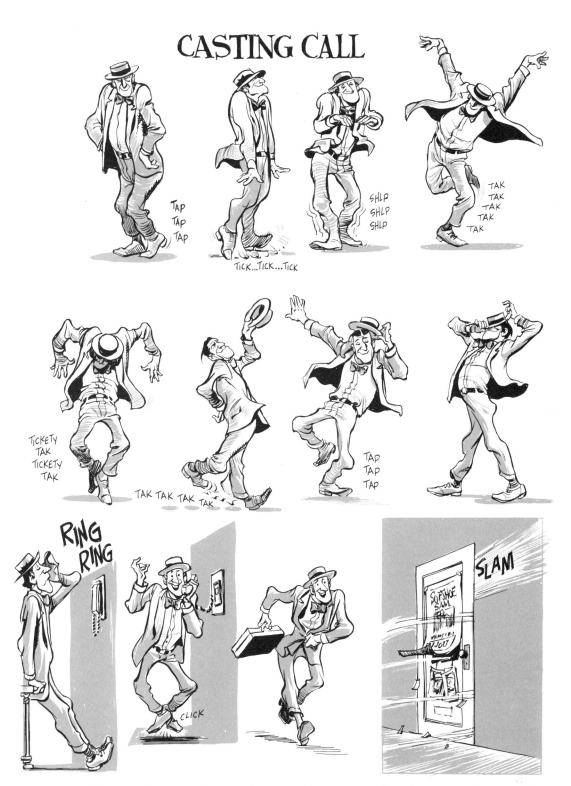

ABOVE: Energy and freedom of movement has always been part of the expression of joy inherent in tap dancing and displayed in "Casting Call" from *Will Eisner Reader*.

GRIEF

The depiction of grief depends upon the cause, the environment, the physique of the character and the age and the culture of the person. Grief can be accompanied by rage, regret, self-pity or by physical acting out that dramatically articulates the feeling. Often the exhibition of grief is repressed, so muscles are controlled to suppress any overt physical action. Depending on the cause and a person's personality, posture and gestures greatly differ. In situations of great loss, the body will seem to sag, shoulder muscles relax, and the head bows in a posture that seems to indicate a desire to withdraw or shrink into hiding. In certain personalities grief may be shown by a gesture of great rage.

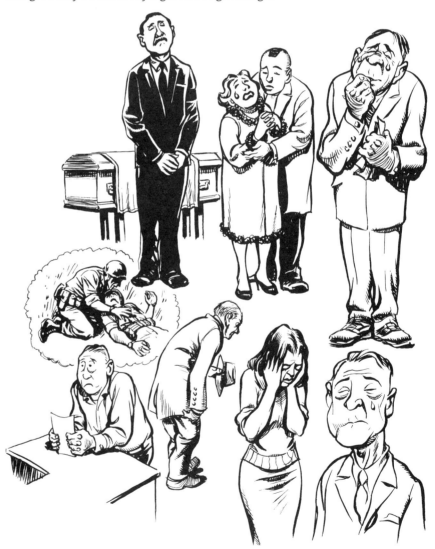

OPERA

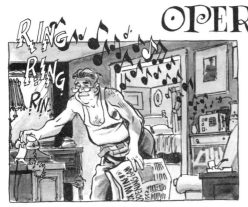
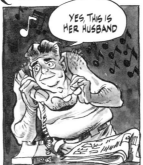
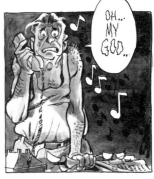
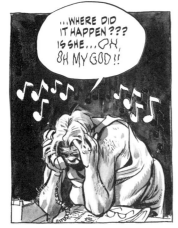
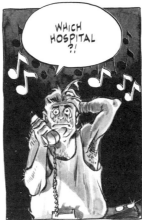
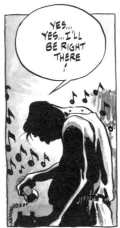
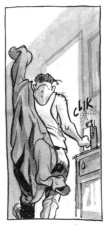
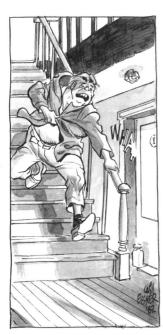
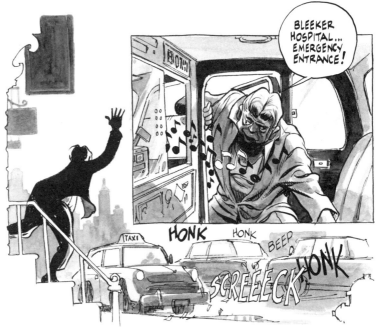

ABOVE: Loss and grief haunt a sad urban dweller across the town accompanied by sounds of the street and music from a tired old jukebox in "Opera" from *New York: The Big City*.

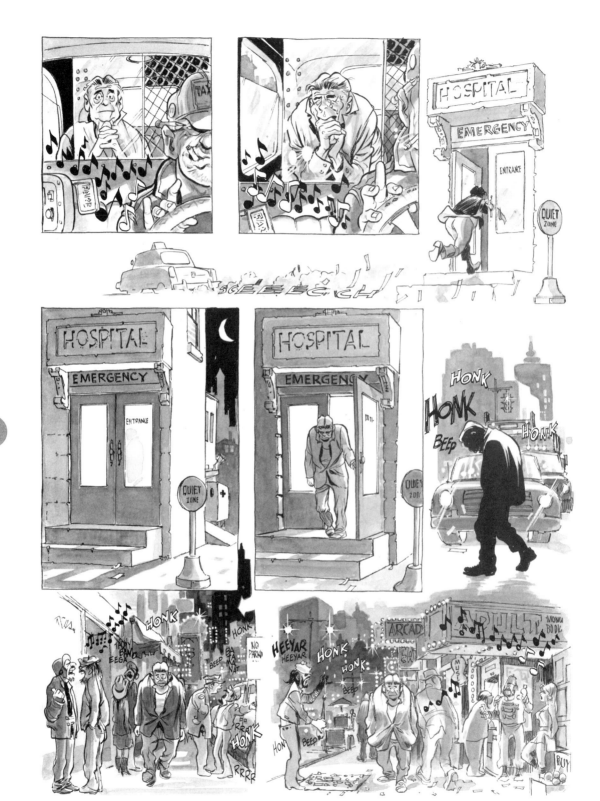

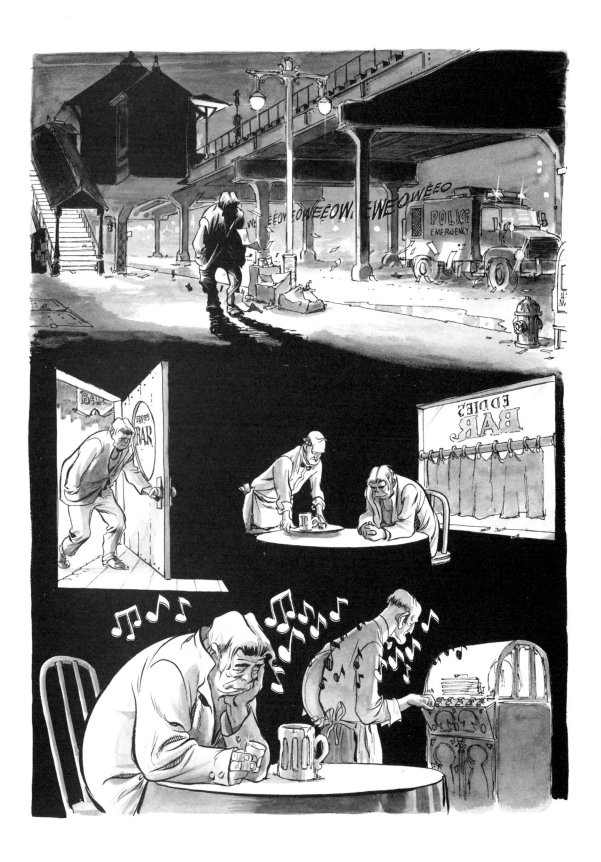

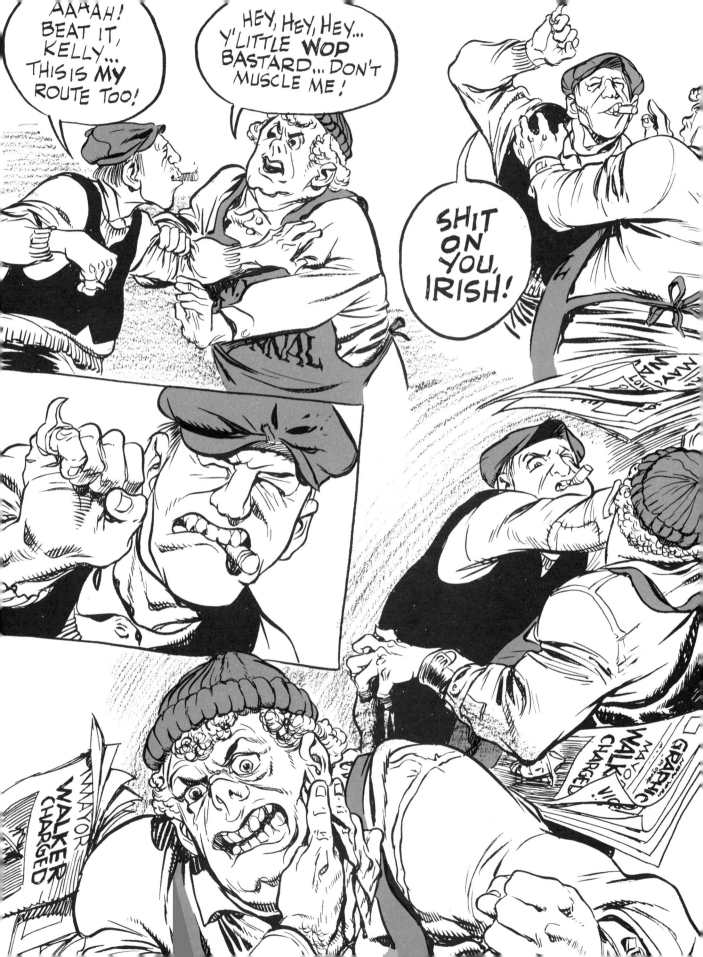

CHAPTER 8

AGGRESSIVE PHYSICAL ACTION

Unlike an emotionally triggered reflex due to pain or its anticipation, most aggressive action by humans is intended and often reasoned. This movement enlists most of the muscles that activate the body's effort to evade and/or deliver a forceful act. To depict such action the artist must take into account the physical characteristics of the actor as well as the cause. In a believable portrayal, whether exaggerated, comic or realistic, the cause of the action or the object of the violence, or a suggestion of its purpose, helps to indicate the force. The same action by a dancer and a boxer demonstrates the difference in the portrayal of power.

OPPOSITE: Racial slurs spark a violent confrontation over newspaper distribution territory in *To the Heart of the Storm*.

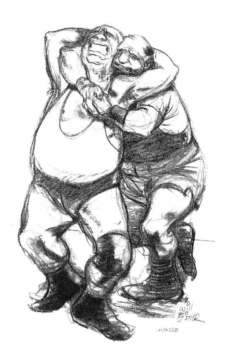

FORCE

In the act of delivering extreme force from a stationary position, the feet serve as an anchor and the pelvis is the fulcrum. In the act of delivering force from a flying position, the shoulder muscles accomplish the job.

NOTE: To illustrate Eisner's point, the following *Spirit* section from April 10, 1949, titled "Lovely Looie," is contrasted with a two-page sequence from *Dropsie Avenue: The Neighborhood*. In the *Spirit* story violence is used for comedic purposes, while in the later graphic novel violence is part of a serious drama.

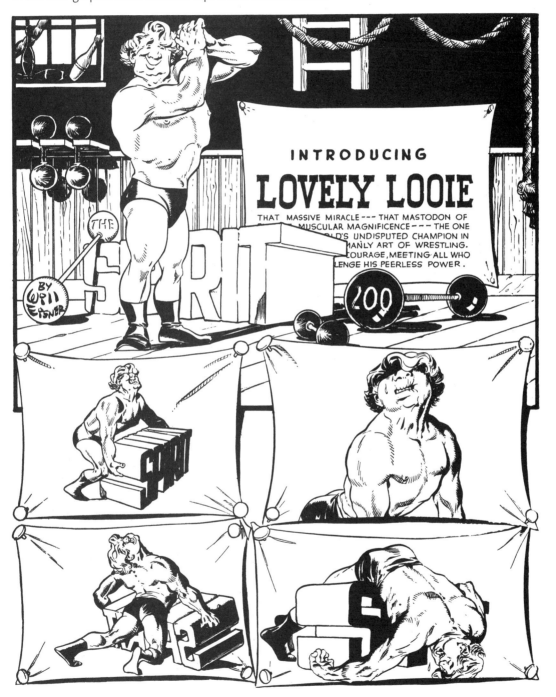

ABOVE AND FOLLOWING PAGES: From "Lovely Looie," in *Spirit* section, April 10, 1949.

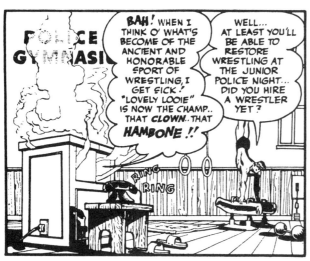

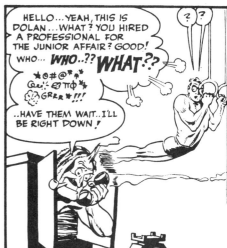

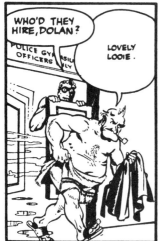

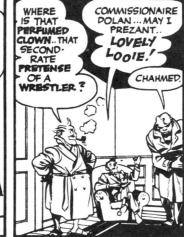

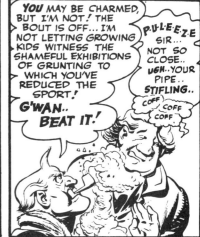

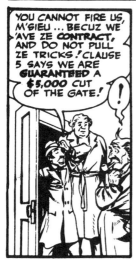

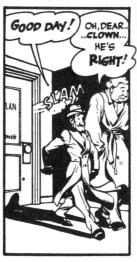

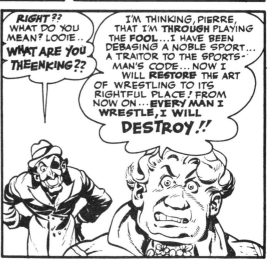

Expressive Anatomy for Comics and Narrative

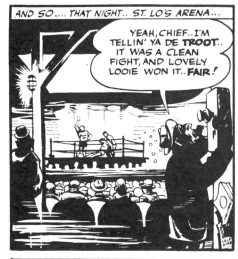

AND SO.... THAT NIGHT... ST. LO'S ARENA...

YEAH, CHIEF.. I'M TELLIN' YA DE **TROOT**.. IT WAS A CLEAN FIGHT, AND LOVELY LOOIE WON IT.. **FAIR**!

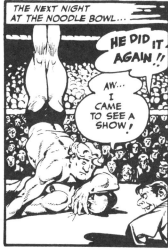

THE NEXT NIGHT AT THE NOODLE BOWL....

HE DID IT AGAIN!!

AW... I CAME TO SEE A SHOW!

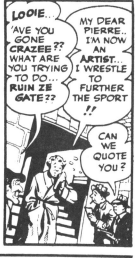

LOOIE.. 'AVE YOU GONE **CRAZEE**?? WHAT ARE YOU TRYING TO DO... **RUIN ZE GATE**??

MY DEAR PIERRE.. I'M NOW AN **ARTIST**... I WRESTLE TO FURTHER THE SPORT!!

CAN WE QUOTE YOU?

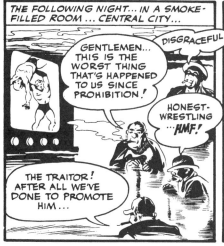

THE FOLLOWING NIGHT... IN A SMOKE-FILLED ROOM ... CENTRAL CITY...

GENTLEMEN... THIS IS THE WORST THING THAT'S HAPPENED TO US SINCE PROHIBITION!

DISGRACEFUL!

HONEST WRESTLING ... **HMF**!

THE TRAITOR! AFTER ALL WE'VE DONE TO PROMOTE HIM...

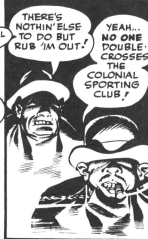

THERE'S NOTHIN' ELSE TO DO BUT RUB 'IM OUT!

YEAH... **NO ONE** DOUBLE-CROSSES THE COLONIAL SPORTING CLUB!

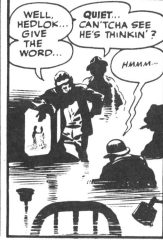

WELL, HEDLOK... GIVE THE WORD...

QUIET... CAN'TCHA SEE HE'S THINKIN'?

HMMM...

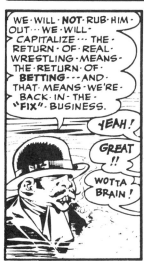

WE·WILL·**NOT**·RUB·HIM OUT···WE·WILL· CAPITALIZE···THE· RETURN·OF·REAL· WRESTLING·MEANS· THE·RETURN·OF· **BETTING**···AND· THAT·MEANS·WE'RE· BACK·IN·THE· "FIX"·BUSINESS.

YEAH!

GREAT!!

WOTTA BRAIN!

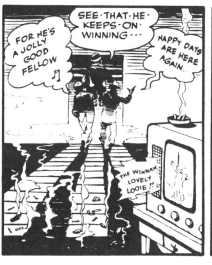

SEE·THAT·HE· KEEPS·ON· WINNING···

FOR HE'S A JOLLY GOOD FELLOW ♪

HAPPY DAYS ARE HERE AGAIN...

THE WINNAH, LOVELY LOOIE!!

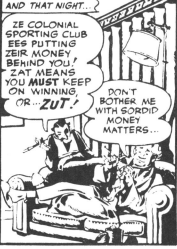

AND THAT NIGHT...

ZE COLONIAL SPORTING CLUB EES PUTTING ZEIR MONEY BEHIND YOU! ZAT MEANS YOU **MUST** KEEP ON WINNING, OR...**ZUT**!

DON'T BOTHER ME WITH SORDID MONEY MATTERS...

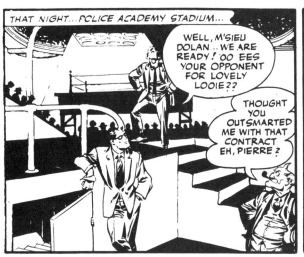

THAT NIGHT...POLICE ACADEMY STADIUM...

WELL, M'SIEU DOLAN...WE ARE READY! 'OO EES YOUR OPPONENT FOR LOVELY LOOIE??

THOUGHT YOU OUTSMARTED ME WITH THAT CONTRACT EH, PIERRE?

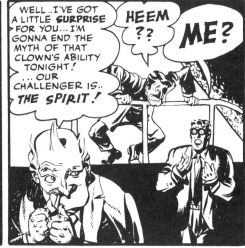

WELL..I'VE GOT A LITTLE **SURPRISE** FOR YOU...I'M GONNA END THE MYTH OF THAT CLOWN'S ABILITY TONIGHT! ...OUR CHALLENGER IS.. *THE SPIRIT!*

HEEM ??

ME?

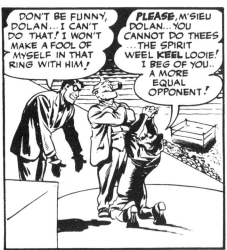

DON'T BE FUNNY, DOLAN...I CAN'T DO THAT! I WON'T MAKE A FOOL OF MYSELF IN THAT RING WITH HIM!

PLEASE, M'SIEU DOLAN...YOU CANNOT DO THEES ...THE SPIRIT WEEL **KEEL** LOOIE! I BEG OF YOU.. A MORE EQUAL OPPONENT!

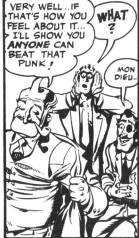

VERY WELL...IF THAT'S HOW YOU FEEL ABOUT IT... I'LL SHOW YOU **ANYONE** CAN BEAT THAT PUNK!

WHAT ?

MON DIEU..

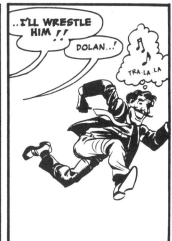

..I'LL WRESTLE HIM !!

DOLAN..!

TRA-LA-LA

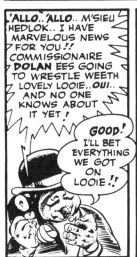

'ALLO..'ALLO.. M'SIEU HEDLOK.. I HAVE MARVELOUS NEWS FOR YOU! COMMISSIONAIRE **DOLAN** EES GOING TO WRESTLE WEETH LOVELY LOOIE..OUI.. AND NO ONE KNOWS ABOUT IT YET!

GOOD! I'LL BET EVERYTHING WE GOT ON LOOIE !!

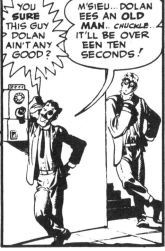

YOU **SURE** THIS GUY DOLAN AIN'T ANY GOOD?

M'SIEU...DOLAN EES AN **OLD MAN**.. CHUCKLE.. IT'LL BE OVER EEN TEN SECONDS!

HMMM...

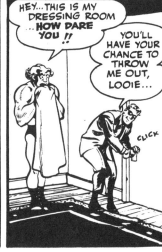

HEY...THIS IS MY DRESSING ROOM ..**HOW DARE YOU** !!

YOU'LL HAVE YOUR CHANCE TO THROW ME OUT, LOOIE...

CLICK

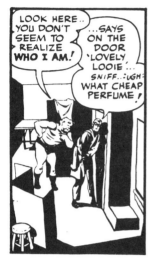

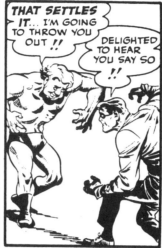

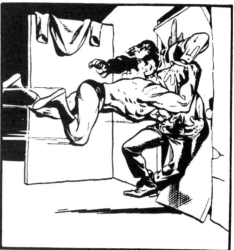

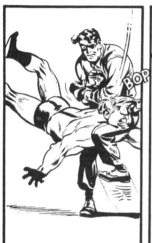

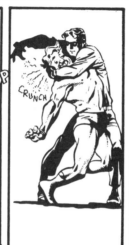

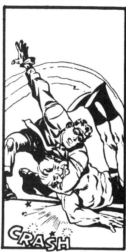

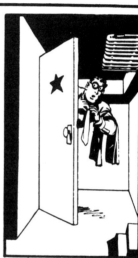

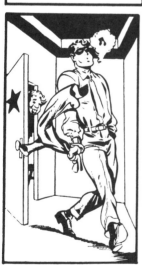

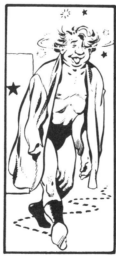

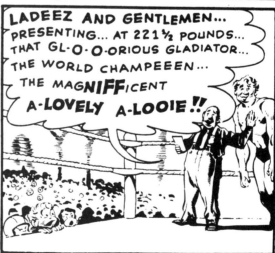

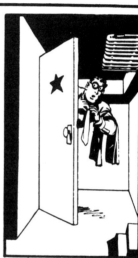

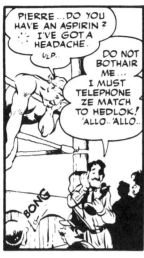

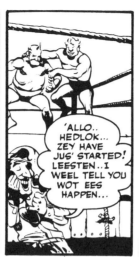

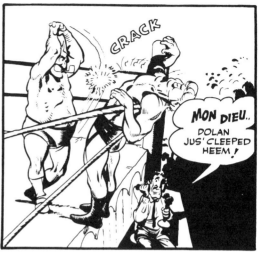

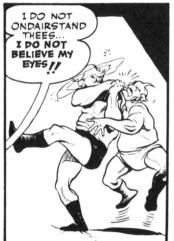

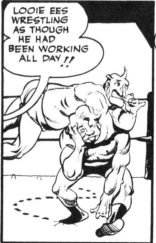

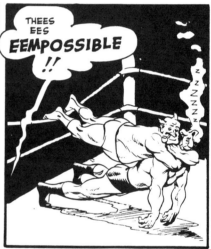

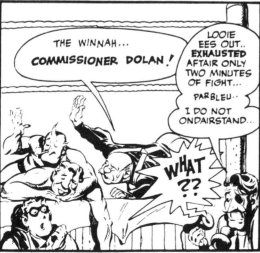

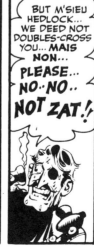

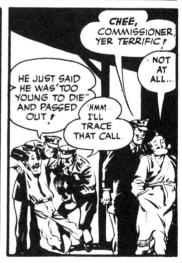

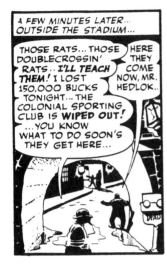

A FEW MINUTES LATER... OUTSIDE THE STADIUM...

THOSE RATS... THOSE DOUBLECROSSIN' RATS... *I'LL TEACH THEM!* I LOST 150,000 BUCKS TONIGHT... THE COLONIAL SPORTING CLUB IS *WIPED OUT!* ... YOU KNOW WHAT TO DO SOON'S THEY GET HERE...

HERE THEY COME NOW, MR. HEDLOK...

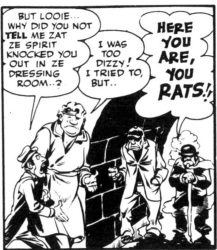

BUT LOOIE... WHY DID YOU NOT *TELL* ME ZAT ZE SPIRIT KNOCKED YOU OUT IN ZE DRESSING ROOM..?

I WAS TOO DIZZY! I TRIED TO, BUT..

HERE YOU ARE, YOU RATS!

PLEASE...YOU ANNOY ME!

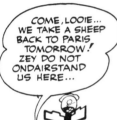

COME, LOOIE... WE TAKE A SHEEP BACK TO PARIS TOMORROW! ZEY DO NOT ONDAIRSTAND US HERE...

NEXT MORNING...

HELLO, KLINK... WHERE'S *MAN-MOUNTAIN DOLAN* THIS FINE MORNING?

HA HA. OUR MIGHTY COMMISSIONER IS IN THE GYM, TEACHING SOME KIDS THE FINE POINTS OF WRESTLING.

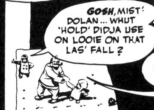

GOSH, MIST' DOLAN... WHUT 'HOLD' DIDJA USE ON LOOIE ON THAT LAS' FALL?

I CALL IT 'THE *DOLAN DANGLE*'. AH... COME HERE, P.S... I'LL DEMONSTRATE! ... DON'T BE AFRAID, LAD... JUST PLACE YOUR HAND HERE..

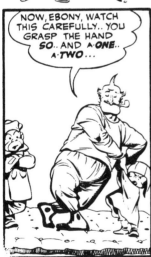

NOW, EBONY, WATCH THIS CAREFULLY.. YOU GRASP THE HAND *SO*.. AND A-*ONE*.. A-*TWO*...

THUD

Aggressive Physical Action

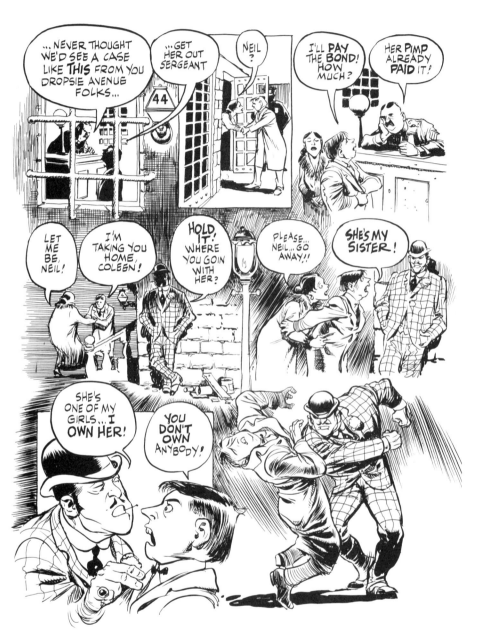

ABOVE AND OPPOSITE: A dramatic conflict with a violent resolution from *Dropsie Avenue: The Neighborhood.*

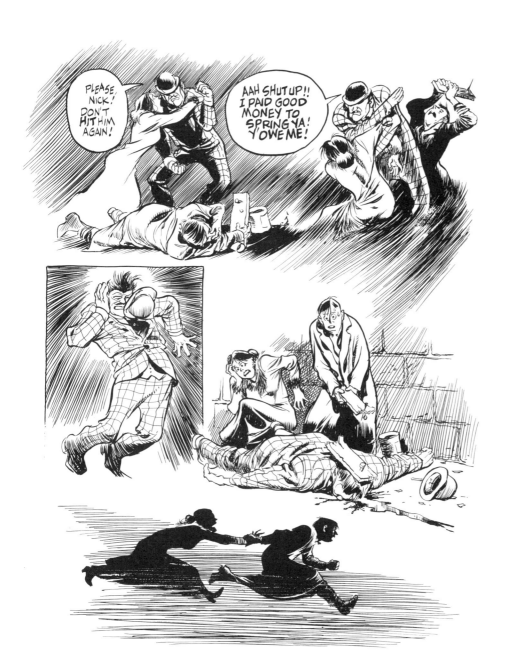

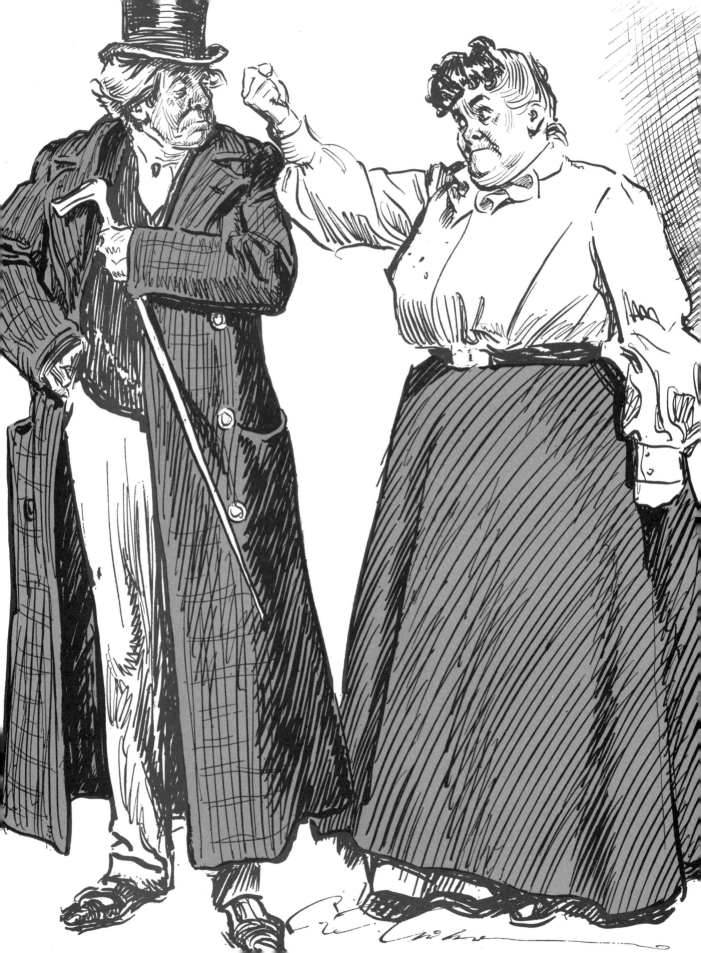

CHAPTER 9
TALKING PICTURES

Around 1900, during the early years of classic newspaper and magazine illustration, one of the great masters of expressive anatomy was Charles Dana Gibson. His single panel illustrations were known as "cartoons" because they often evoked humorous situations of the known social interactions of the time. They were fine examples of brilliant art and draftsmanship. He produced art that involved the execution of a form of graphic dialogue. Underneath each picture were lines of text that were either commentary or conversation. The art was so clearly recognizable in posture and gesture that the imagery was a readable language in itself and needed little support from words. Gibson's mastery of human anatomy was crucial to its success, as the following examples of "Studies in Expression" and "The Widow and Her Friends" from the old *Life* magazine demonstrate.

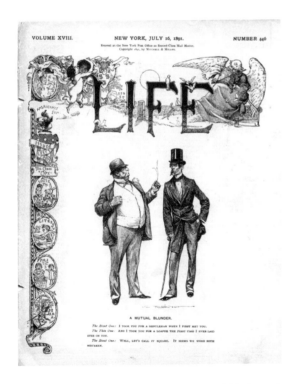

OPPOSITE: An impeccable image of large readable line art with well-observed characters and subtle gestures.

RIGHT: *Life* magazine cover, July 16, 1891.

Manager: UNLESS YOU BRACE UP I'LL HAVE TO BREAK OUR CONTRACT.
"DON'T SAY THAT! I HAVE A CHILD AND TWO HUSBANDS TO SUPPORT."

ABOVE: "The Theatre Manager and the Female Performer" uses theatrical lighting and stereo-typical attitudes.

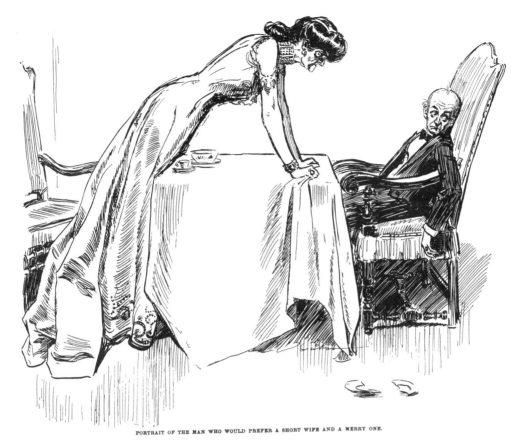

PORTRAIT OF THE MAN WHO WOULD PREFER A SHORT WIFE AND A MERRY ONE.

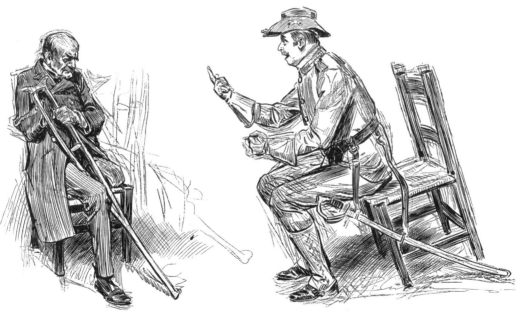

STUDIES IN EXPRESSION.
WHILE A SPANISH-AMERICAN HERO DESCRIBES THE HORRORS OF WAR.

ABOVE: Two of Gibson's realistic renderings of comic confrontations from 1902.

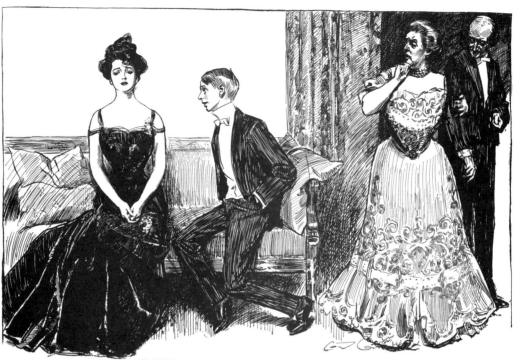

MRS. DIGGS IS ALARMED AT DISCOVERING WHAT SHE IMAGINES TO BE A SNARE
THAT THREATENS THE SAFETY OF HER ONLY CHILD. MR. DIGGS DOES NOT
SHARE HIS WIFE'S ANXIETY.

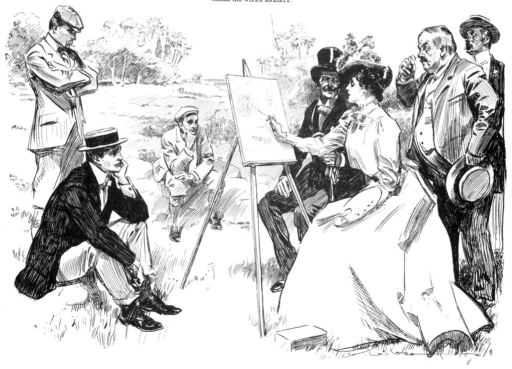

ABOVE: Two illustrations from the series "The Widow and Her Friends" remind the reader of "The Gibson Girl," a benchmark of beauty for the early twentieth century.

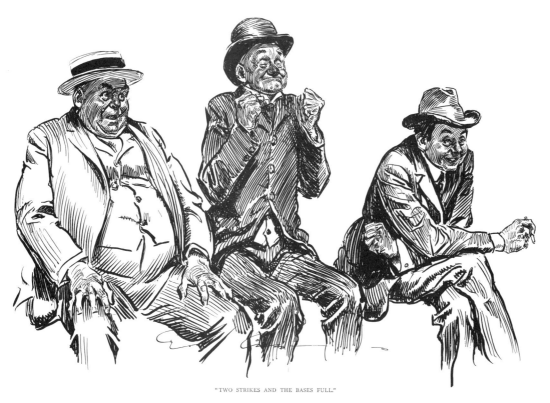

"TWO STRIKES AND THE BASES FULL."

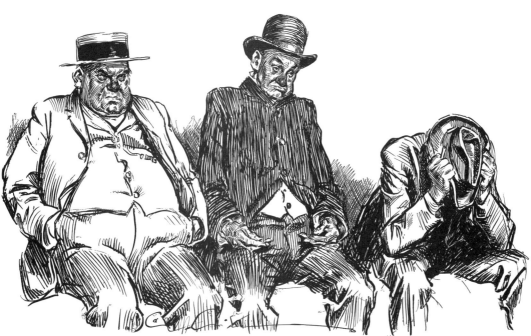

"FANNED OUT"

ABOVE: Gibson humorously depicts the timeless action and reaction, and elation and depression of baseball fans with these two illustrations for the old *Life* magazine.

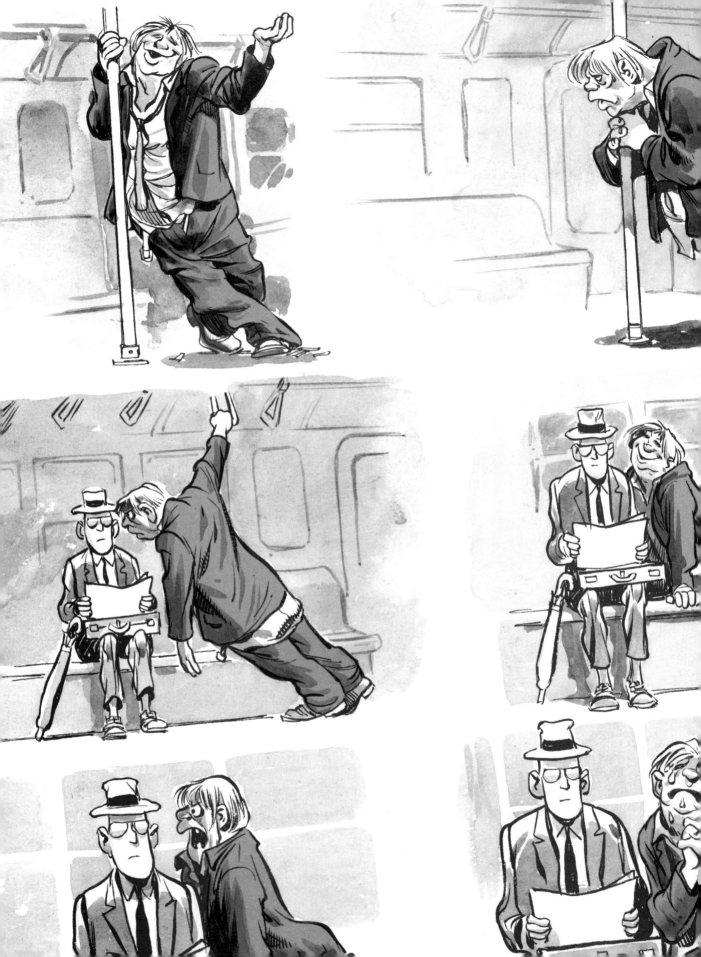

CHAPTER 10
PHYSICAL COMMUNICATION

When portraying human conduct the draftsman will be dealing with functional anatomy. It is the function and capacity of the human skeleton to respond to the dynamics of communication between people. Studies show that a surprisingly small percentage of live human communication is verbal. Actually the postures, the gestures of the body, and the movement of the extremities are the major elements of person-to-person conversation. The mind and the brain are constantly arranging the actions of muscles and bones in service of expressing emotions that accompany a message. We refer to these actions as postures and gestures. In the execution of sequential art that is created for the print medium, static figures are not simply an illustration of an accompanying body of text, but instead, they embody a universally understood vocabulary that can transmit dialogue without any words at all. The question of whether spoken words precede or follow posture is debatable. But, as we discussed earlier, this book assumes the latter. Postures and gestures are the alphabet of the graphic language.

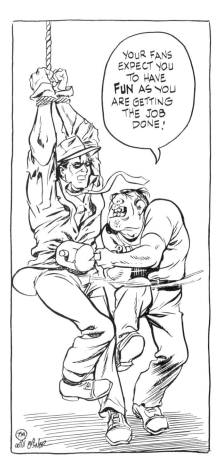

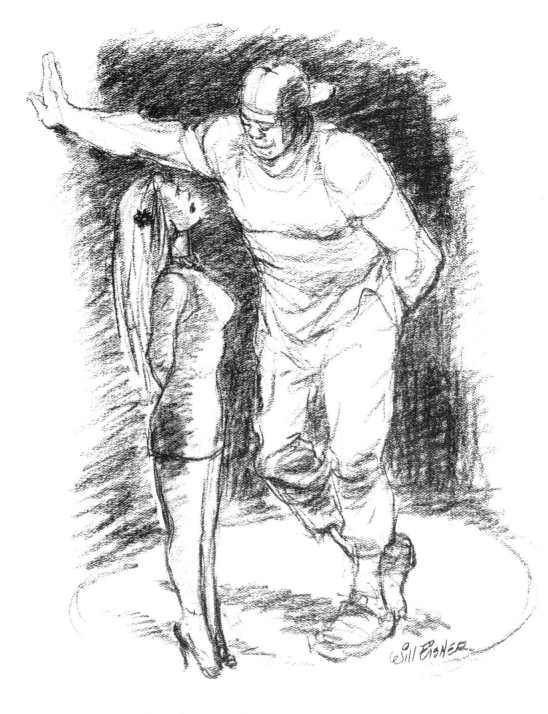

ABOVE: A crayon drawing by Will Eisner that expresses through body language the major social, political and economic situations of a romantic confrontation.

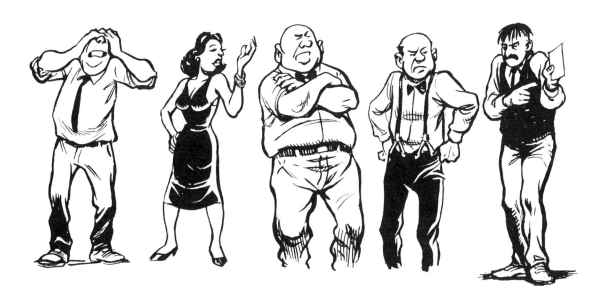

HOW THE SKELETAL STRUCTURE SUPPORTS THE GESTURE Removing oneself from something objectionable or distasteful.

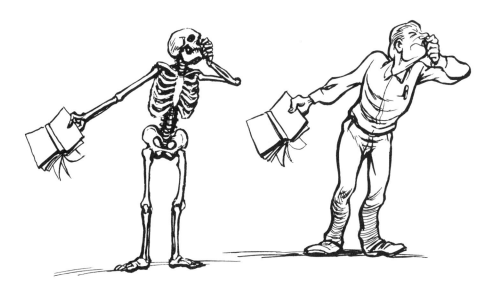

HOW THE SKELETAL STRUCTURE SUPPORTS THE GESTURE The silent indication of serious thought or contemplation.

HOW THE SKELETAL STRUCTURE SUPPORTS THE GESTURE Simulating helplessness with a gesture of the hands and rising shoulders to indicate emptiness.

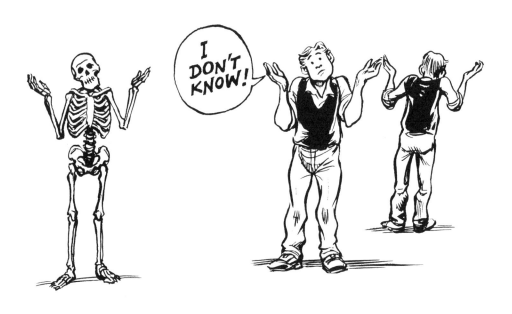

HOW THE SKELETAL STRUCTURE SUPPORTS THE GESTURE In a position of firmness: arms doing something positive, showing control.

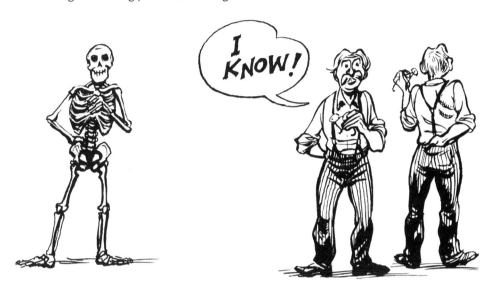

HOW THE SKELETAL STRUCTURE SUPPORTS THE POSTURE Poised for fright: one hand raised for protection while the feet begin to spin the body around in the opposite direction.

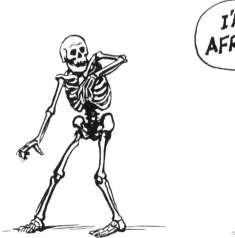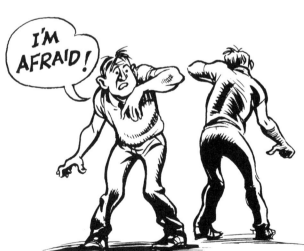

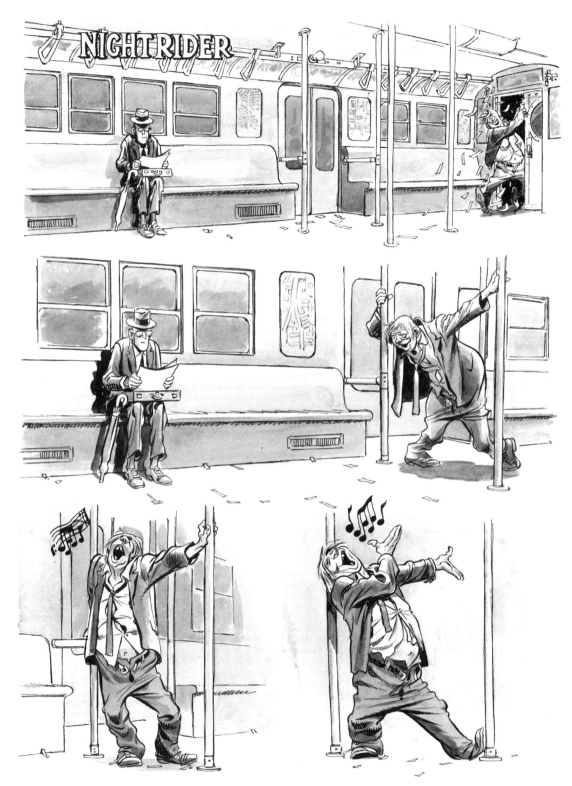

ABOVE AND OPPOSITE: The irresistible (intoxicated) force meets the immovable (commuter) object on the last train home with contrasting body grammar, from *New York: The Big City*.

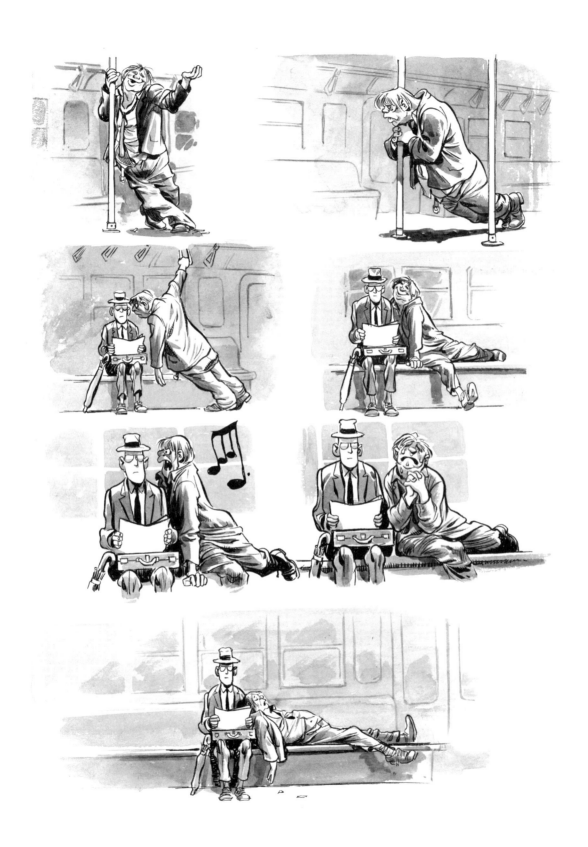

PHYSICAL POSITIONING

Most oral communication is accompanied by physical gestures, postures and adjustment of the space between the persons communicating.

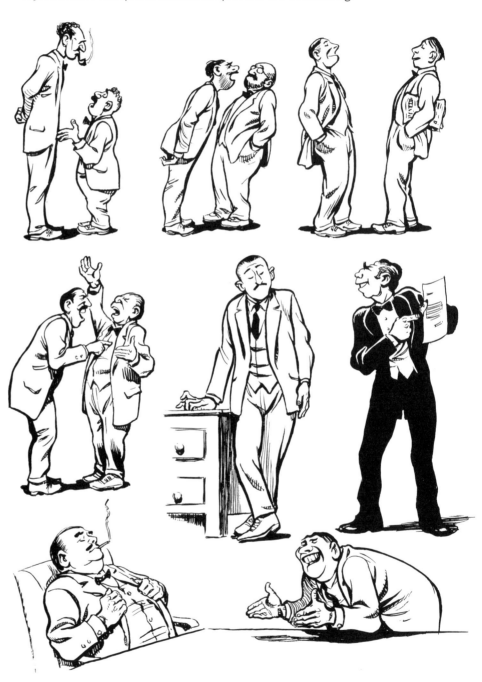

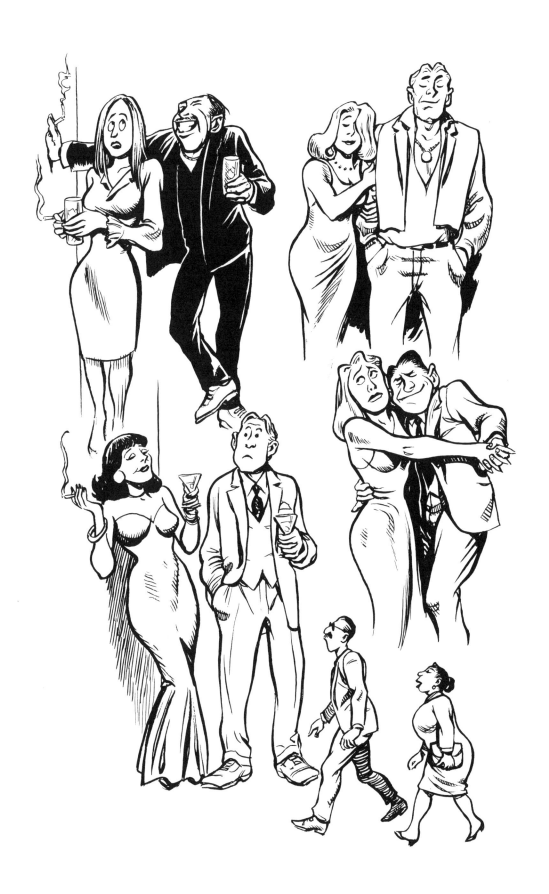

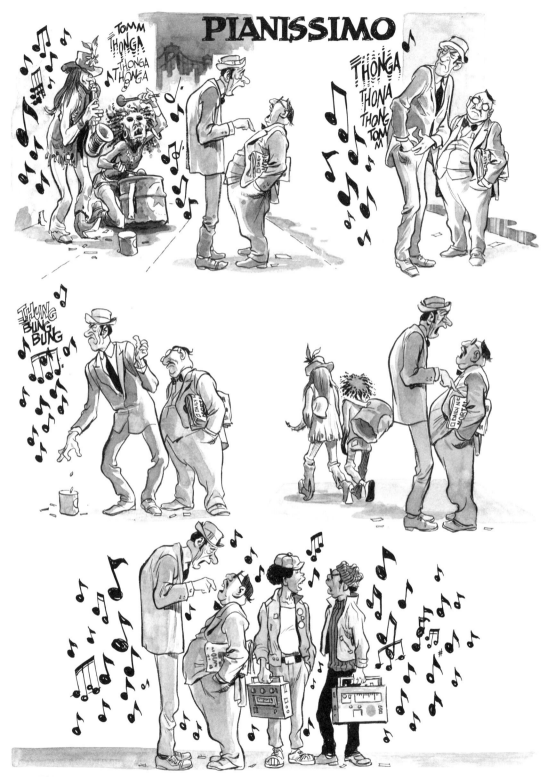

ABOVE: This private conversation just can't seem to escape loud musical accompaniment, from *New York: The Big City*.

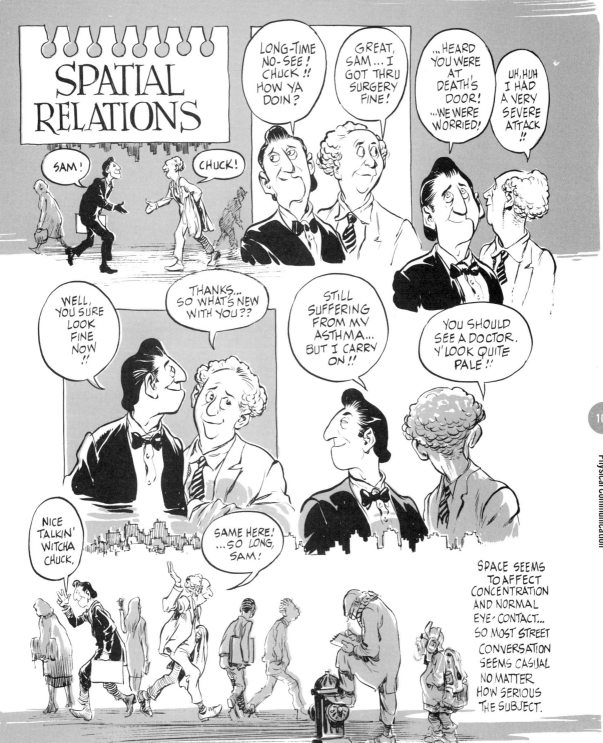

ABOVE: The comical body grammar of urban dwellers with the inability to look people in the eye when talking to them, observed by Will Eisner in *City People Notebook*.

CHAPTER 11

USING THE EXPRESSIVE CAPACITY OF THE HUMAN BODY

Graphic storytelling or comics is the use of an intelligent sequence of images to narrate a story. The human images in it, often supported with dialogue, have an important narrative function, and the artist must select them carefully from a seamless flow of motion in his imagination and then put them down on paper to effectively express the scene he has imagined. These selected images are, in fact, a vocabulary in a graphic language. They are understandable because the reader himself has experienced such situations, has recognized the actions of the body, and has learned to interpret the meaning of certain basic positions. Thus, in narrative action, we assume that the mind determines the message while the brain generates the visual display that either supports or illustrates a happening with only a minor use of words.

OVERLEAF: Pastor Brown is concealed to witness a demonstration of the powers of Morris the healer in "The Power," from *Invisible People*. Depending on how a sequence containing unheard dialogue is visually constructed for the reader to digest, the need for words to describe an internal emotion of a character can be superfluous.

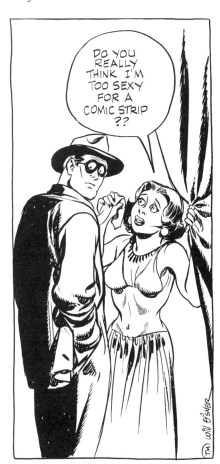

THE SILENT OBSERVER

By following the body grammar of the pastor from moment to moment, panel by panel, the reader understands the subtle emotional reactions of doubt, outrage, disbelief and, finally, disapproval, in a sequence which only lasts a single page.

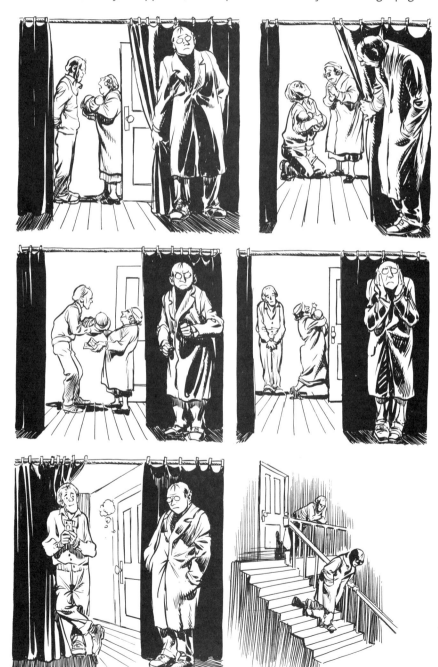

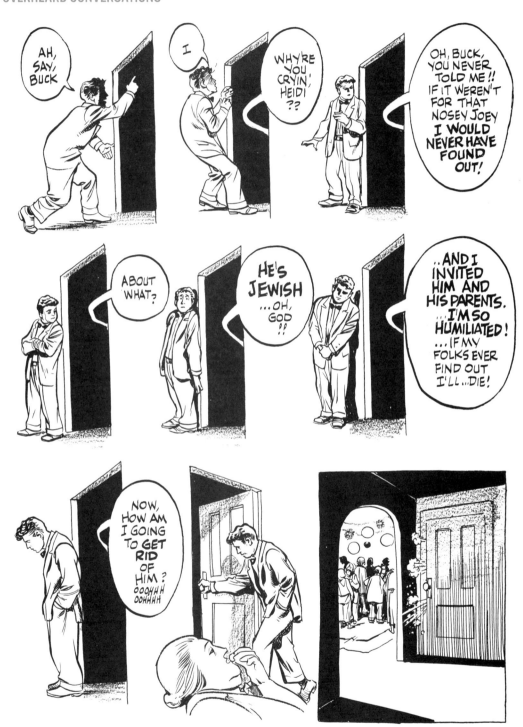

ABOVE: Young Willie Eisner's body grammar runs through anticipation, embarrassment, attentiveness, surprise, sadness and maybe depression overhearing the rejection and the anti-Semitic statements of a pretty girl he likes.

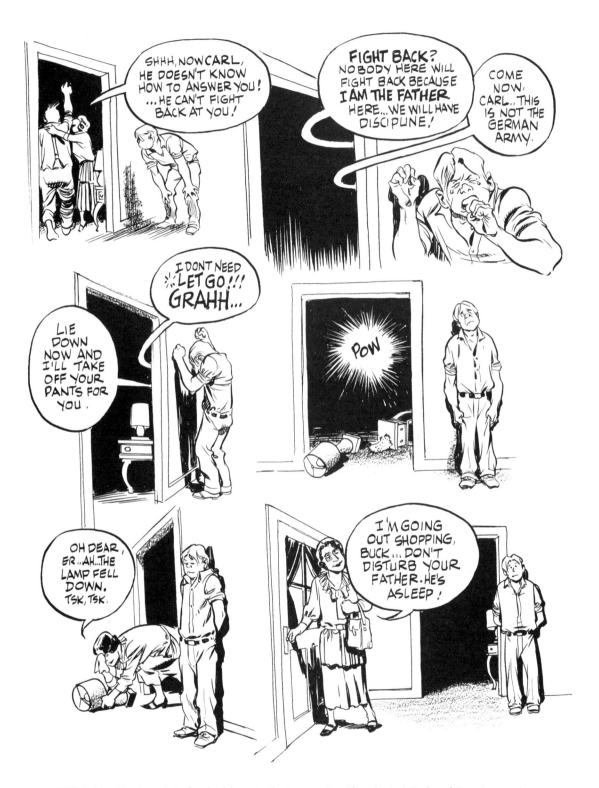

ABOVE: Willie's friend Buck reacts to family violence in the tenements with a physical display of despair, powerlessness, shame and detachment. Here bolder text balloons can sometimes compete with the figure attitudes for added emphasis and expression. This and the following page are from *To the Heart of the Storm*.

FAMILY DYNAMICS

The body grammar at family gatherings exhibits numerous and different body types of size, weight, age and gender interacting intimately and spontaneously. An artist should consider the hierarchy of the family: which people in the scene are in charge?

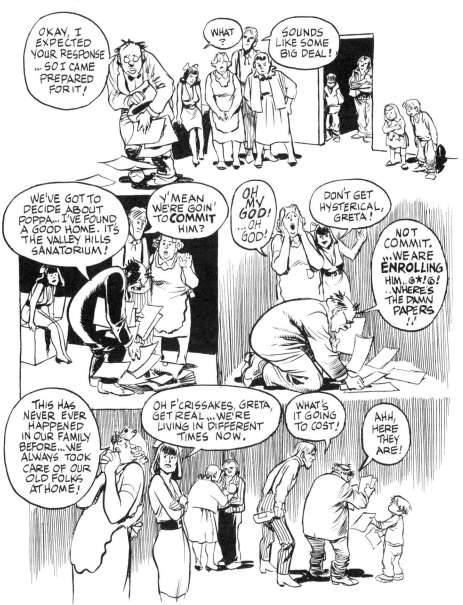

ABOVE AND OVERLEAF: In these two pages from *Family Matter*, randomness prevails until the call to order for dinner brings everyone to their assigned place at table.

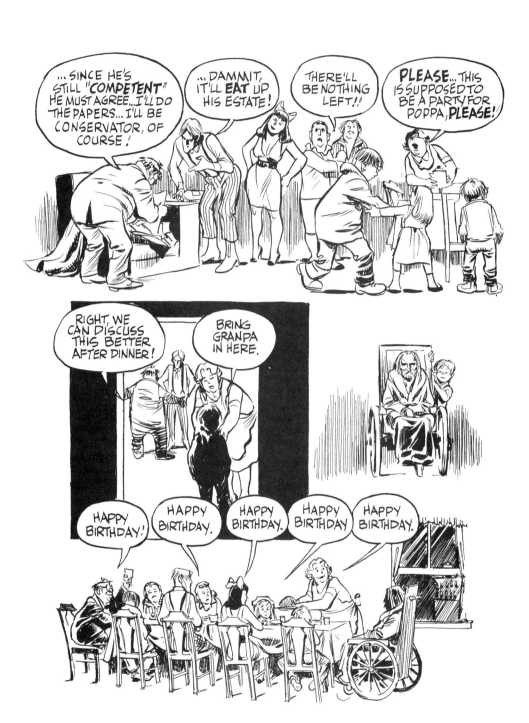

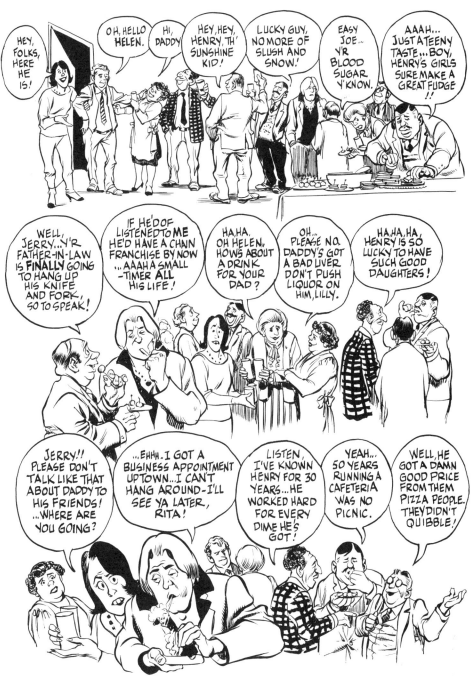

ABOVE AND OVERLEAF: Across two pages from "A Sunset in Sunshine City" (*Will Eisner Reader*) of a crowd gathering for a going-away party, Eisner uses an ebb and flow rhythm like the tide of the ocean coming in and going out to usher the reader through a gallery of types.

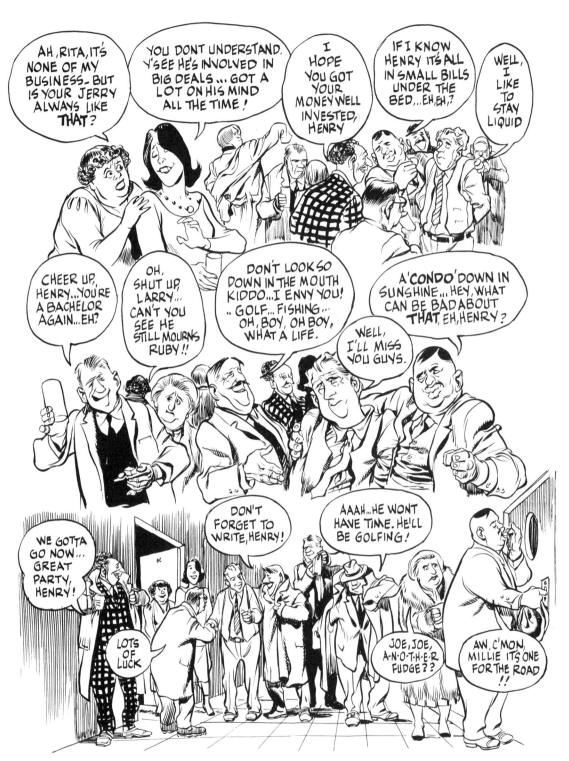

ABOVE: A wave of friends and neighbors of various ages and genders casually arrives with close-ups of certain individuals splashing to the forefront speaking with informal gestures until the final line-up of figures withdrawing at the end of the evening.

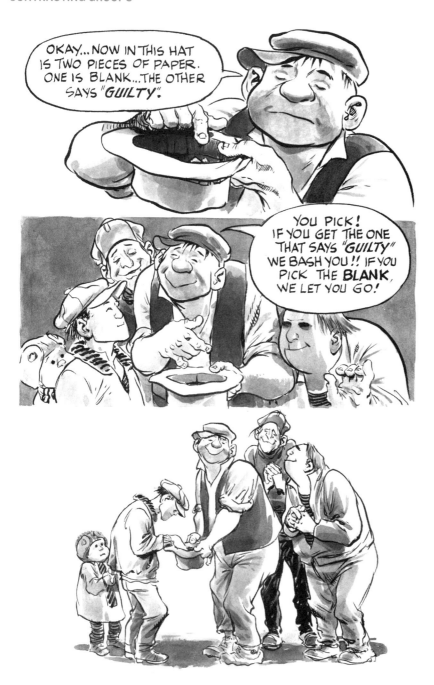

ABOVE AND FOLLOWING PAGES: An example of figure groups acting as units: two versus three, small versus big, smart versus dumb, in this humorous David and Goliath situation from Eisner's past, titled "Street Magic," from *Minor Miracles*.

Depicted comically twice as large as the two smaller boys, the body language of the bullies is a direct reflection of each other's pose establishing their group mentality, while all three mug directly at the reader. The lack of a background aids in the readability of the group postures and gestures almost as if they were performing on stage.

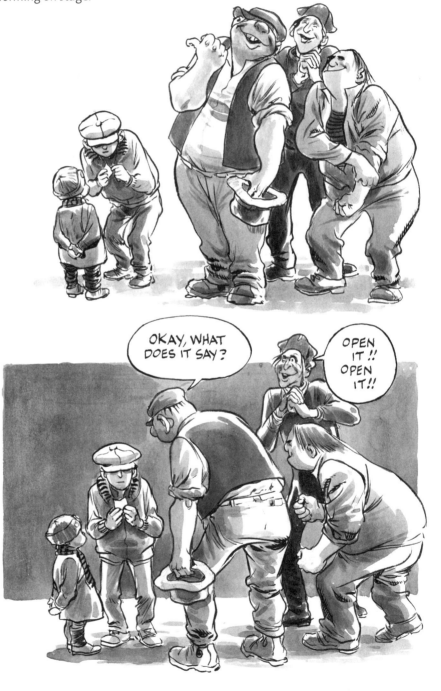

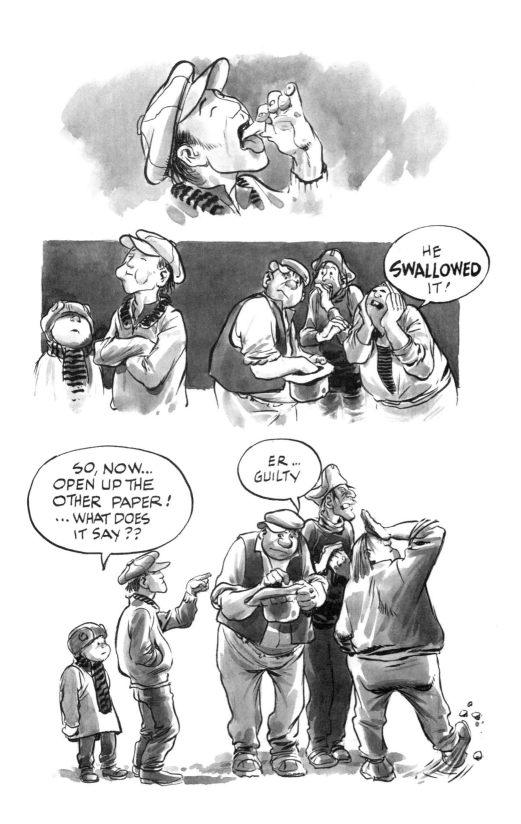

THE COMPENSATING BODY

When one part of the body is unable to function, the rest of the frame alters its action accordingly. Neighboring muscles, responding to the demand for greater usage by the able parts, become stronger and move other parts of the body to

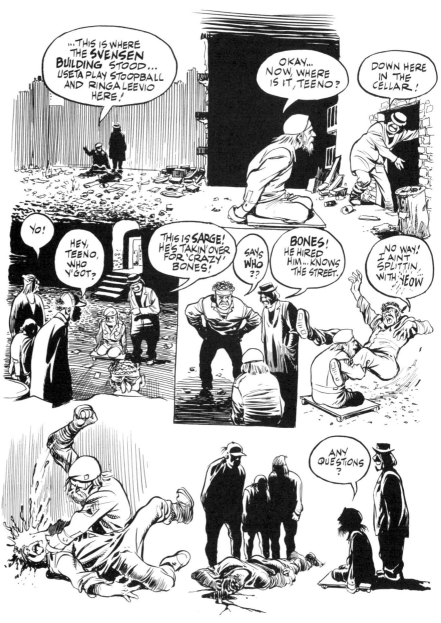

ABOVE: Sarge returns home from Vietnam an amputee, but that doesn't stop him from taking over drug territory in *Dropsie Avenue: The Neighborhood*.

compensate for the disability. When depicting this action, the interaction of mind and brain must be considered because the mind may want to accomplish an action beyond what the anatomy can accommodate. Also, the environment is a factor in staging the action.

ABOVE: Eisner wrote and drew several sequences in which the Spirit was blind or disabled and on crutches in the late 1940s.

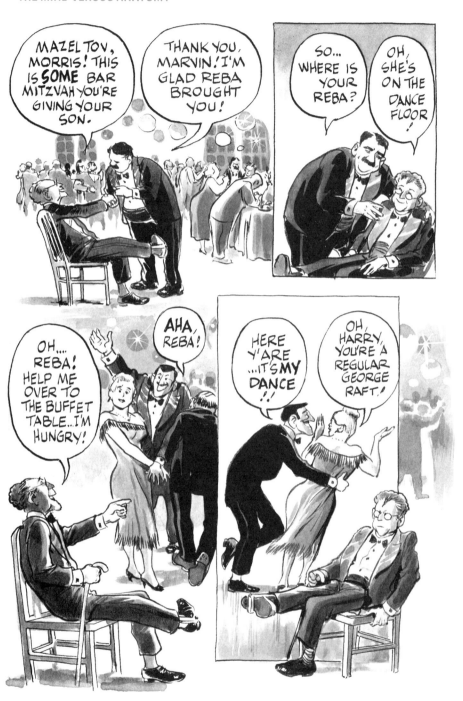

ABOVE AND OPPOSITE: Feeling ignored, jealous and angry at his own physical limitations, Marvin attempts to join the dance in "A Special Wedding Ring" from *Minor Miracles*.

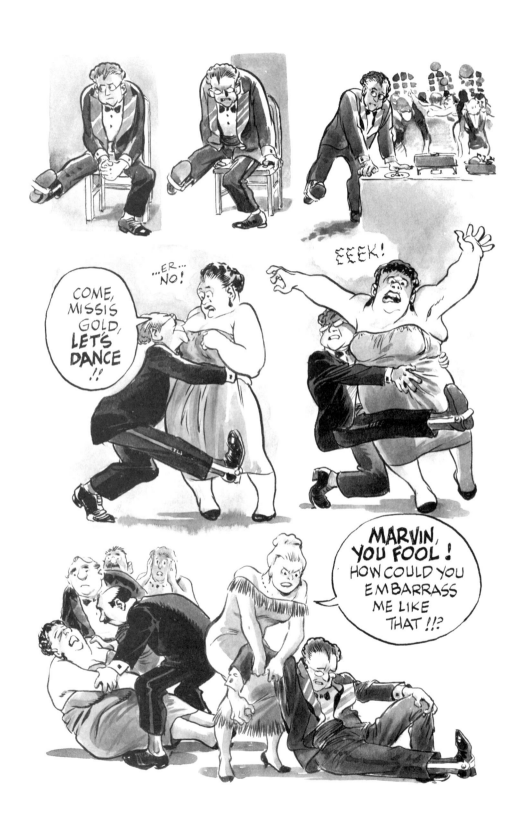

Using the Expressive Capacity of the Human Body

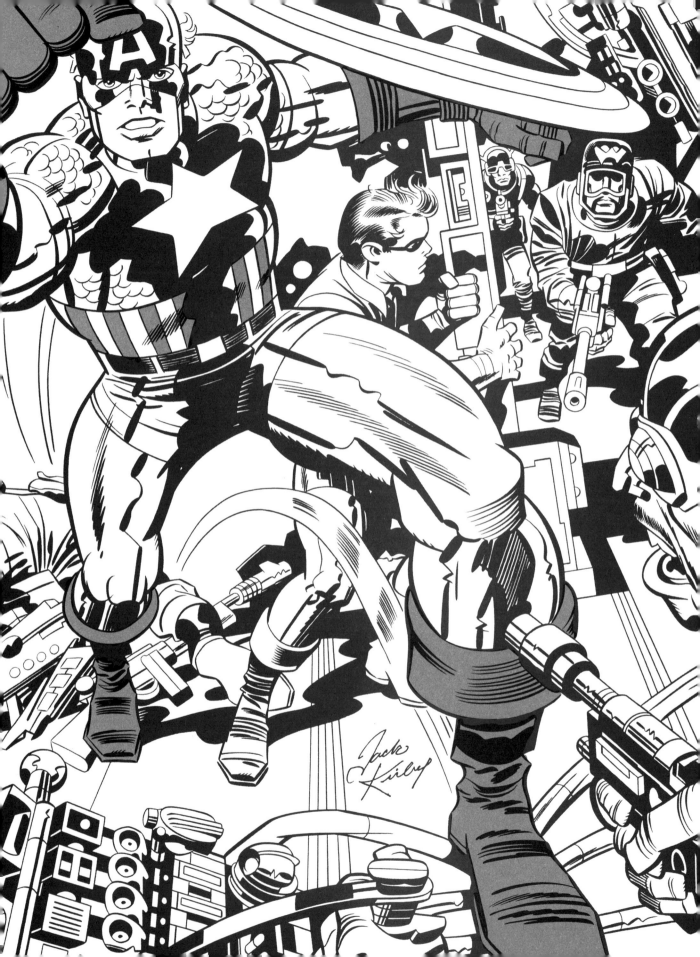

CHAPTER 12

POSTURE AND POWER

Jack Kirby, acknowledged by many as the King of comic book artists, reigned during the rise of the American comic book superhero. His heroic images that exuded sheer power dominated comic books beginning in the mid-1950s and for over twenty-five years thereafter. His masterful depiction of the human body enabled him to effectively portray people in extreme actions despite the limitations of anatomy by amplifying the body's ability to express emotion. The accuracy of the underlying structure enabled him to employ the simplification and exaggeration that is needed to portray power and brute force.

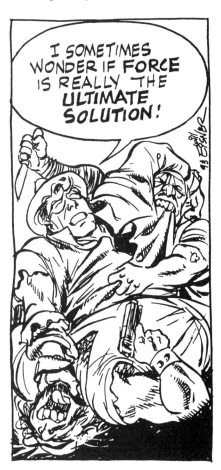

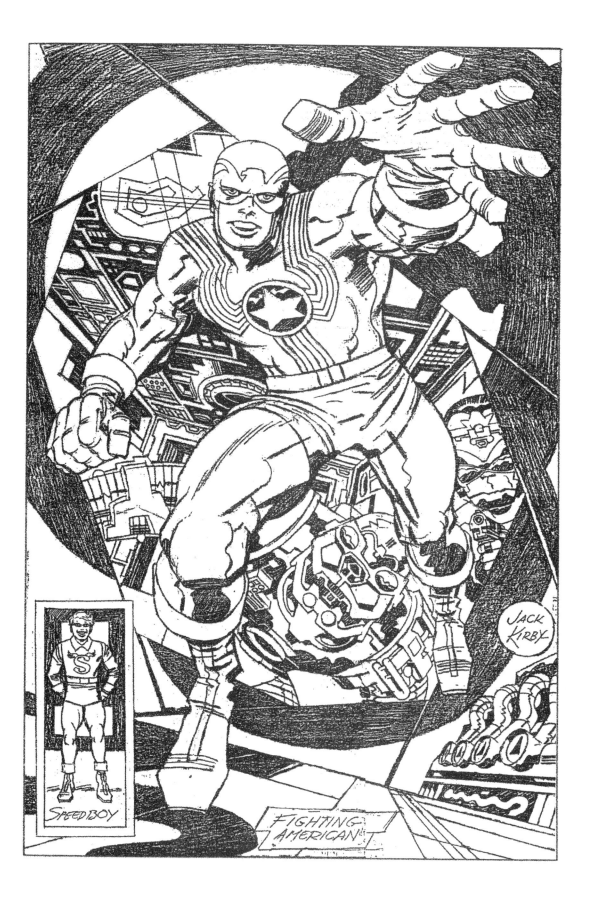

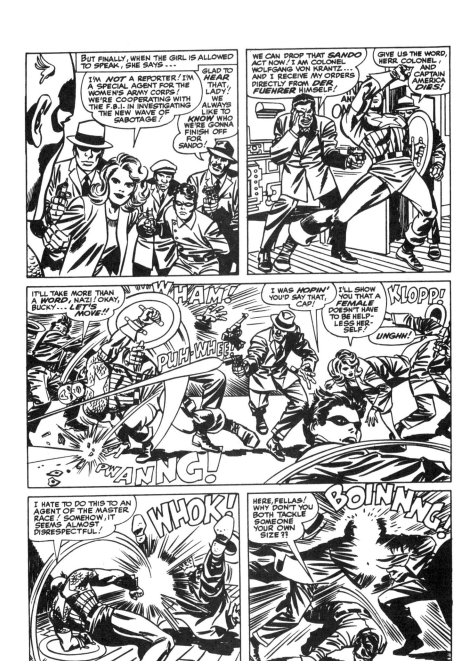

Posture and Power

ABOVE AND FOLLOWING PAGES: Non-stop action from a *Captain America* story, "Among Us, Wreckers Dwell," drawn by Jack Kirby and inked by Frank Giacoia, which appeared in *Tales of Suspense #64*, April 1965.

OPPOSITE: A Fighting American leaps out at the reader from a 1978 pencil drawing by Joe Simon and Jack Kirby. The use of exaggerated foreshortening and extreme multiple perspectives creates a heightened sense of graphic movement.

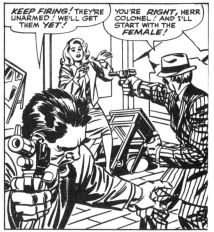

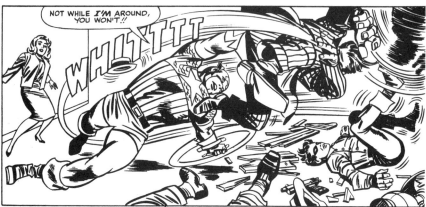

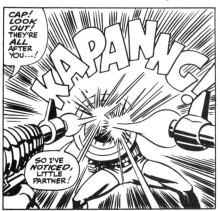

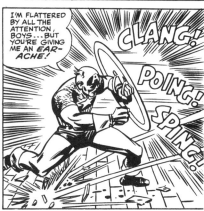

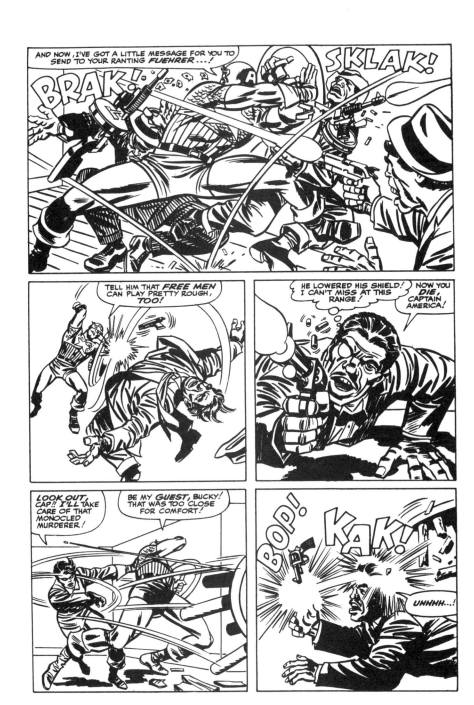

Kirby's drawing became the basis for the look of Marvel Comics in the 1960s when, in collaboration with Stan Lee, he created the Fantastic Four, the Incredible Hulk and a host of other immortal comics characters.

CHAPTER 13

ANATOMY, STAGING AND THE TOTAL COMPOSITION

The selection of body posture and movement necessary to further the development of a story is akin to writing music for song lyrics. Basic knowledge of the simple mechanics of human anatomy provides the confidence with which a gesture is chosen. It is inhibiting to the successful "acting" and expression to be unable to believably depict a human action in a sequence of events that require sensitivity to subtle and unspoken emotions. The following "roughs" from *Dropsie Avenue: The Neighborhood* and *Fagin the Jew* demonstrate the initial staging of an idea as compared with the final printed version. All changes in posture, gesture, and in point of view of the "actors" were made in order to make the understanding of the plot logical to comprehend and easy for the reader to follow.

OPPOSITE: "A Big Mistake," a crayon drawing of a figure expressing pain and regret by Will Eisner.

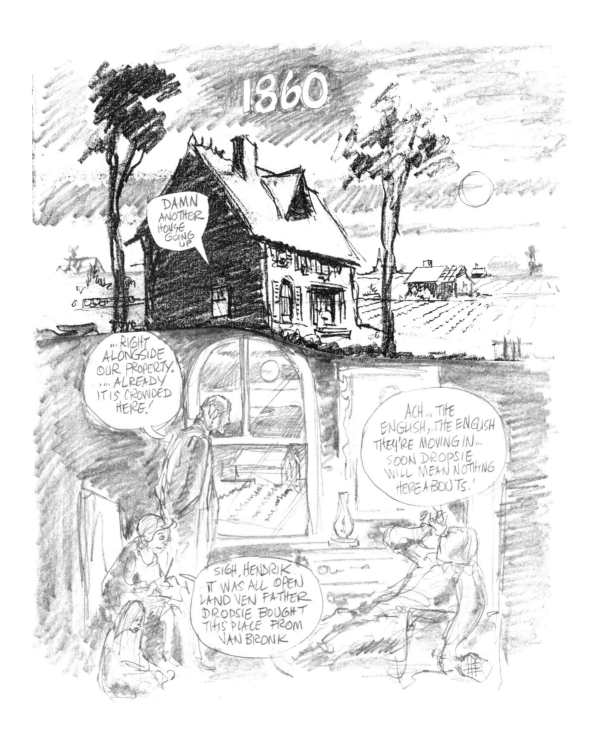

ABOVE: In the penciled rough for page two of *Dropsie Avenue: The Neighborhood*, Eisner immediately establishes the locale— an old Dutch farm—and contrasts the exterior environment with the interior of the house and the family group within.

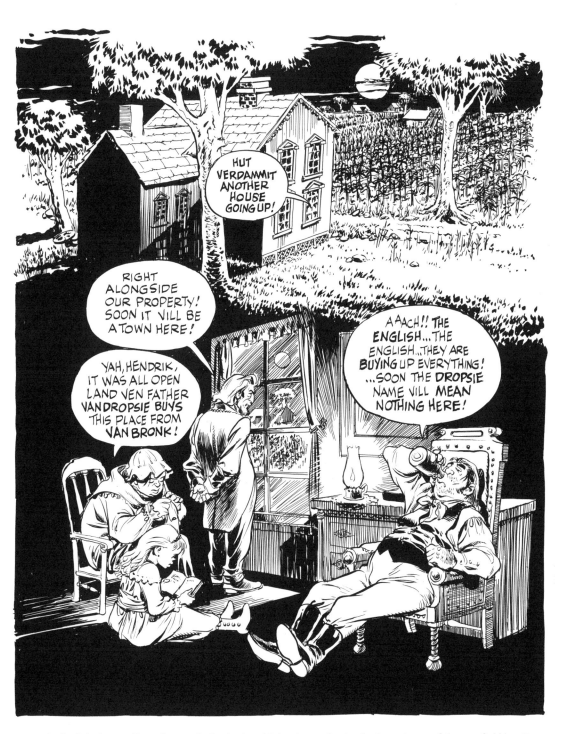

ABOVE: In the inked page, Eisner has made the horizon higher to emphasize the importance of the cornfield location, and Uncle Dirk the drunkard is given larger prominence, thus this page composition connects an exterior landscape to an interior figure.

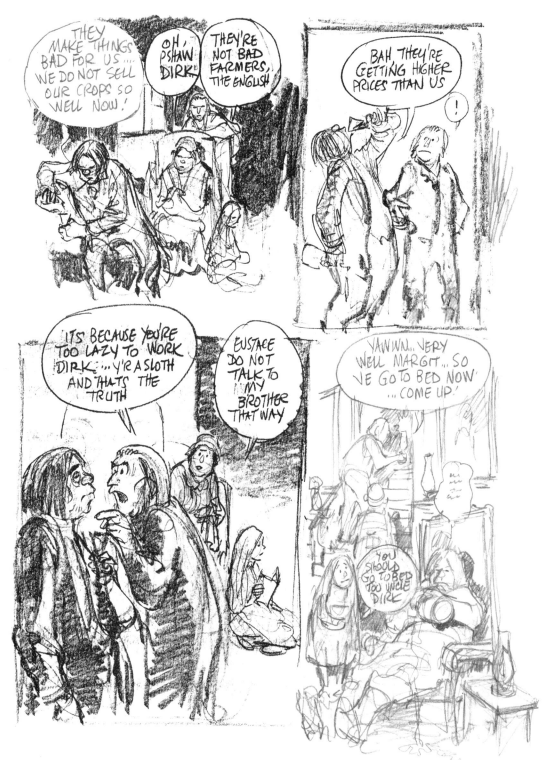

ABOVE: Eisner blocks out the movements of the Dutch family within the house discussing farming and revealing their own characters as well. Here Eisner also chooses which scenes will have a panel outline to separate them from the other scenes for readability.

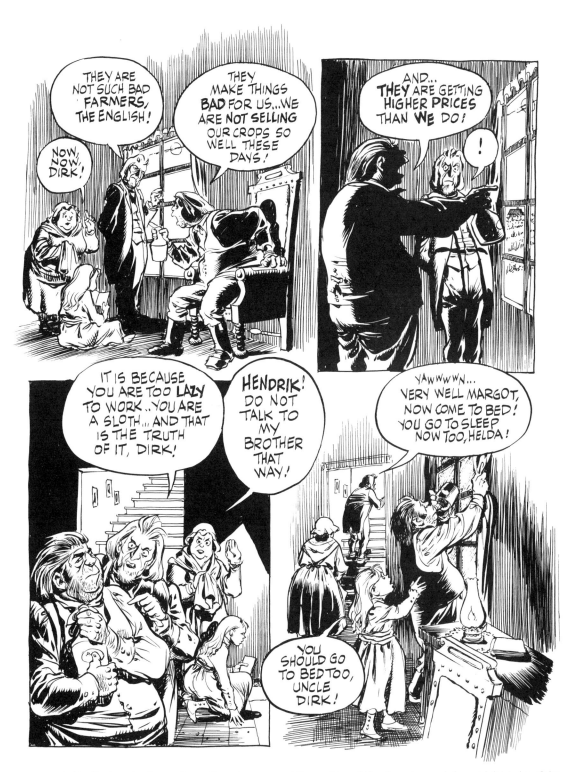

ABOVE: In the final version in panel one, Eisner has reversed the position of the characters and changed the order of the dialogue balloons. Each actor speaks. In the fourth panel, Uncle Dirk remains standing at the window to suggest the action continues next page.

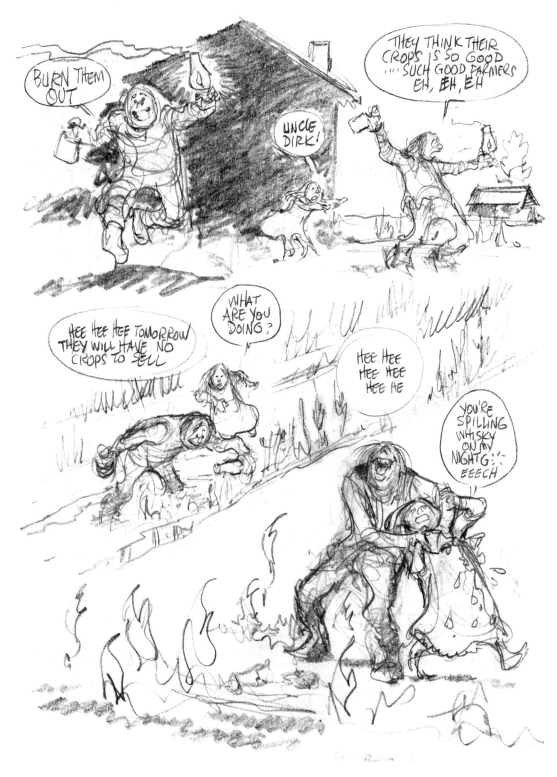

ABOVE: In the rough of Uncle Dirk burning the fields, Eisner blocks out the action of this figure like a diagram to follow with no attention to details. The silhouette of the house shifts the scene outside and little Helda struggles in her drunken uncle's clutches.

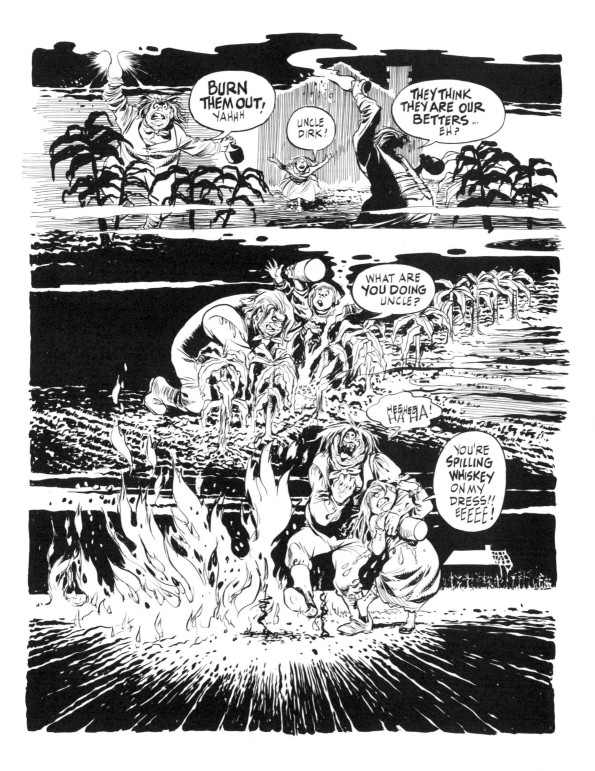

ABOVE: In the inked page, Eisner uses the lamp and fire to light the scene, throwing the larger figure group into main focus. His expressive pen and brush technique creates a textual display that adds to the drama. The boldface dialogue balloons add urgent emphasis.

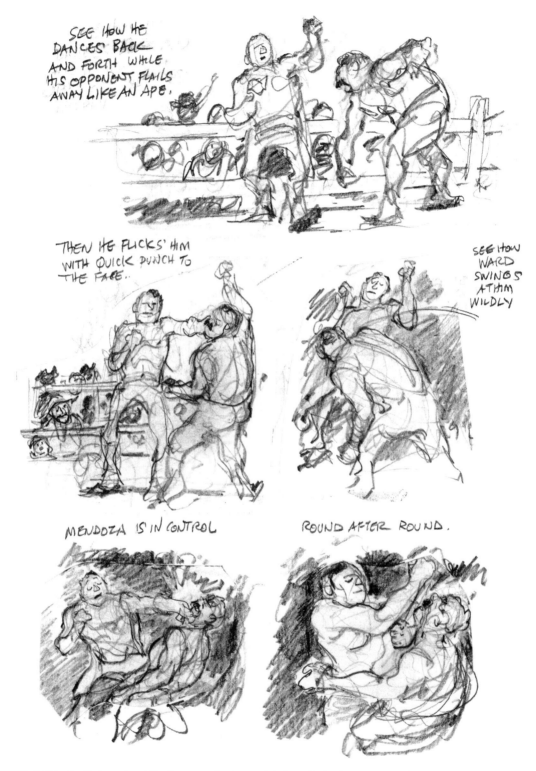

SEE HOW HE DANCES BACK AND FORTH WHILE HIS OPPONENT FLAILS AWAY LIKE AN APE.

THEN HE FLICKS' HIM WITH QUICK PUNCH TO THE FACE.

SEE HOW WARD SWINGS AT HIM WILDLY

MENDOZA IS IN CONTROL

ROUND AFTER ROUND.

ABOVE: In the penciled roughs of the two-page boxing match from *Fagin the Jew*, Eisner choreographs the fight like a dance with a swing-punch-swing-punch-punch, swing-swing-punch-down rhythm count. An outside voice describes the action.

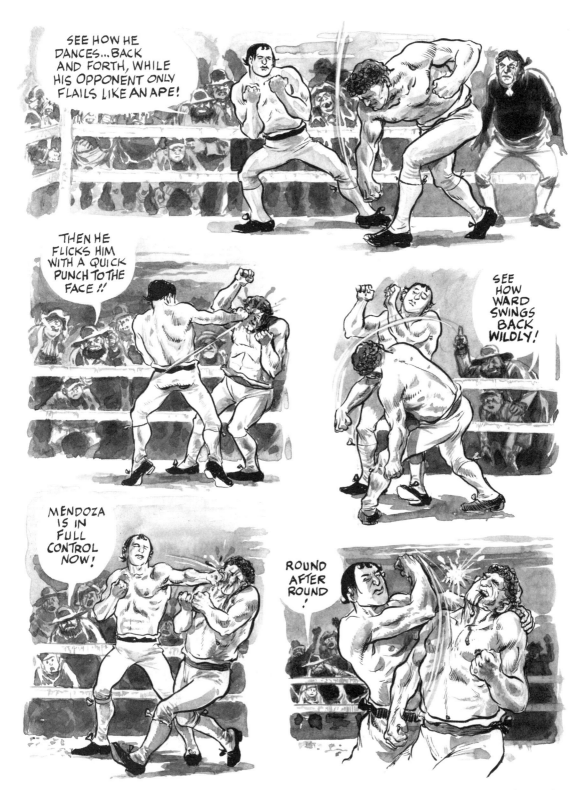

ABOVE: In the finished ink-and-wash page, the background crowd is now developed and the commentary is by Fagin's father. The fighters are drawn in full figure and in continuous motion until a tighter two-shot is used to pull the reader into the action.

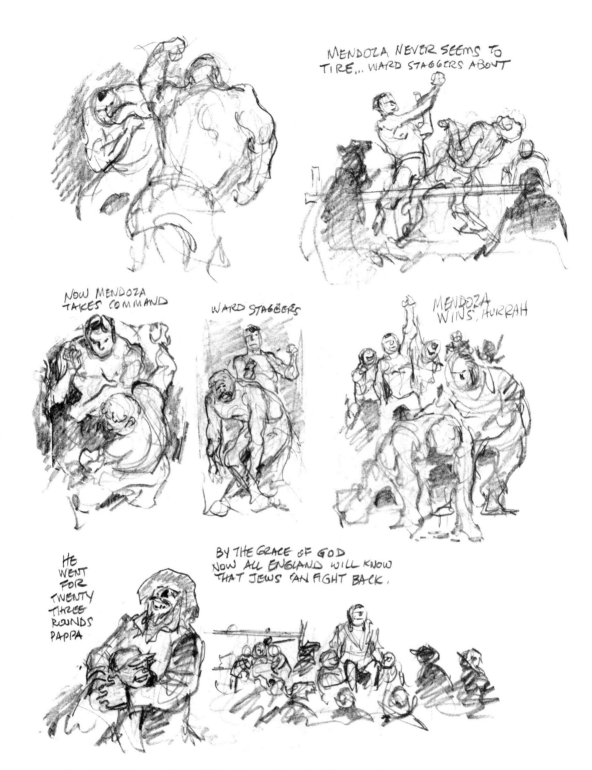

The handwritten text within the sketches reads:

MENDOZA NEVER SEEMS TO TIRE... WARD STAGGERS ABOUT

NOW MENDOZA TAKES COMMAND

WARD STAGGERS

MENDOZA WINS, HURRAH

HE WENT FOR TWENTY THREE ROUNDS PAPPA

BY THE GRACE OF GOD NOW ALL ENGLAND WILL KNOW THAT JEWS CAN FIGHT BACK.

ABOVE: Since in the first page of the fight Eisner's point of view (and the reader's) was from inside the boxing ring with the combatants, he now begins to reverse tack and shift the point of view back and forth to outside the ring with the crowd overlapping the battle.

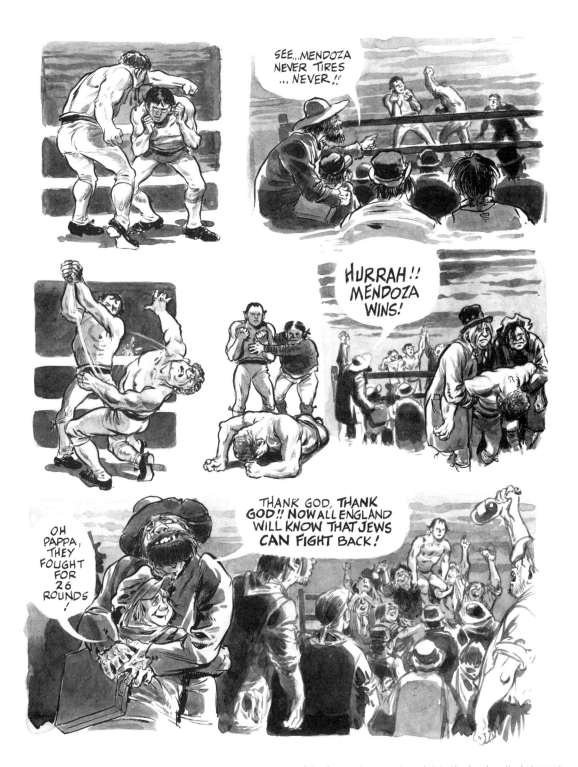

ABOVE: In the inked second page, the silent violent action of the boxers is a counterpoint to the loud excited viewer in the crowd. The visual body language of the fight dovetails with the verbal reaction by Fagin's father (in bold lettering) to Mendoza's victory.

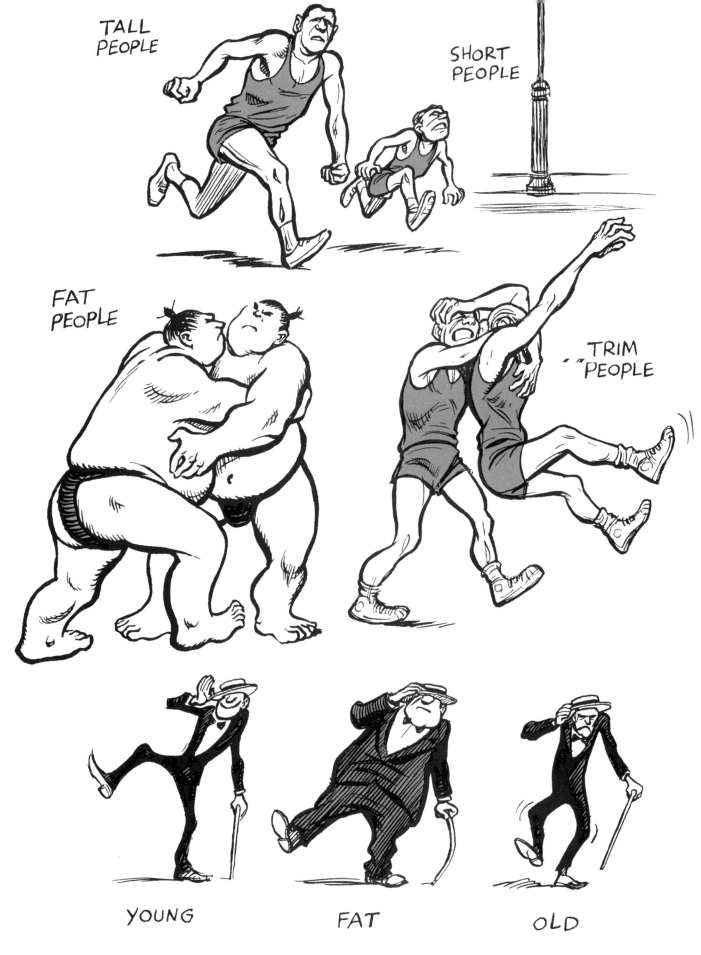

TALL PEOPLE

SHORT PEOPLE

FAT PEOPLE

TRIM PEOPLE

YOUNG FAT OLD

CHAPTER 14
ANATOMY AND STEREOTYPE

The stereotype is an essential part of the language of comics and sequential art. In the creation of a character, physical differences help make the character recognizable to the viewer, visually unique from the other characters, and "readable" when their image, which must be repeated again and again during the course of a story unfolding, has to put in an appearance. Alterations to the basic pattern of human anatomy enable the artist to portray personality and character or a particular "type." The term stereotype originates in the printing process in which an image or type is cast in metal and impressed into a prepared paper mold from which a cast is made to provide an unchangeable image that can be repeated. This term has become a description of a portrayal of a person to indicate his or her personality, race, and type of employment. In narrative art it is an essential part of the visual language. Because of its ability to communicate quickly and without interpretation, stereotype often has been employed to defame or vilify in order to shape public opinion. As a result, stereotype has become an uncomplimentary word. When it is used to hurt someone, it is regarded as an evil device. Unfortunately, it is burdened by literary prejudice even when it is used inoffensively. Nonetheless, because of its importance to the art of graphic narration, mastery of stereotype, based on the memory of physical characteristics made during the observation of common human conduct, should become a fundamental skill.

OPPOSITE: Body types and stereotypes.

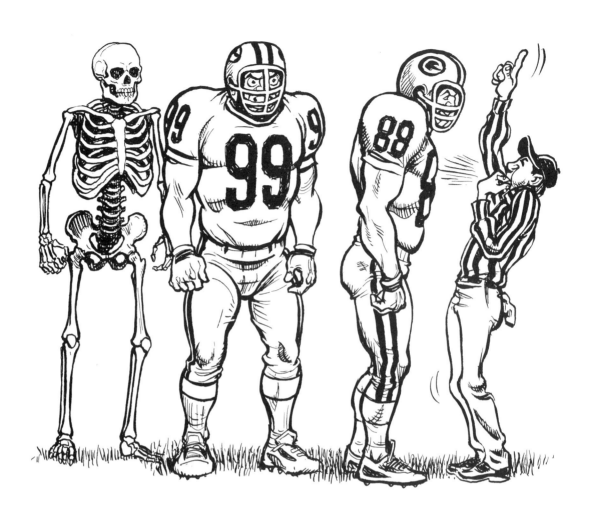

BASIC TYPES: THE STRONG AND THE WEAK

An alteration of the skeleton as well as differences in muscular and surface extremities is inherent in a visual stereotype. A physically strong character should possess a bone structure larger than the average, muscles larger than average, and a posture that is either erect or slightly forward leaning.

In comparison, a physically weak character might be a person engaged in obviously less strenuous work: a clerk, accountant, doctor, lawyer, etc. The bone structure might then be smaller and thinner, making the muscles, neck and shoulder span smaller, causing a posture that might be depicted as a bit stooped with little round shoulders.

Muscular formations can indicate an activity and provide a stereotype.

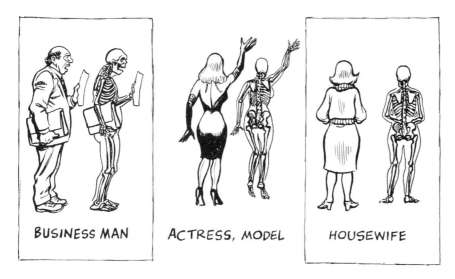

Costume and attire can modify anatomy in stereotype, but not if the physical structure violates the reader's reasoning.

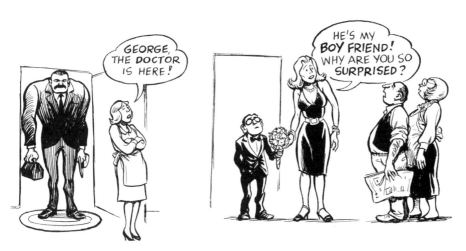

CHAPTER 15
PHYSIOGNOMY

Commonly, the face is the part of the body that attracts most immediate attention. The first process in recognizing a person is most often a scan of the face. Artists throughout the ages have used faces to make a study of character, a good example of which is this study by the British painter and printmaker William Hogarth who was also a critic and satirist who depicted his time in popular sequential engravings. In the early development of sequential art, a study of the type-revealing modifications of the human face was made by Rudolph Topffer, who called it "physiognomy." Topffer (1799–1846) was a Swiss artist who lectured on classic rhetoric at the Academy of Geneva and who experimented with graphic narrative. His comic picture story *The True Story of Monsieur Crépin,* which he produced in 1837, was admired by the great German author, Goethe. It was the forerunner of the comics we know and read today. At the time Goethe commended, "If for the future, he would choose a less frivolous subject and restrict himself a little, he would produce things beyond all conception."

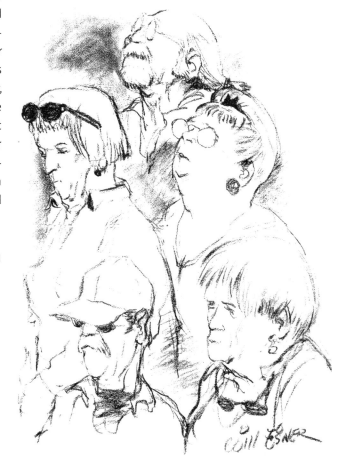

RIGHT: A crayon drawing by Will Eisner titled "Lecture Audience."

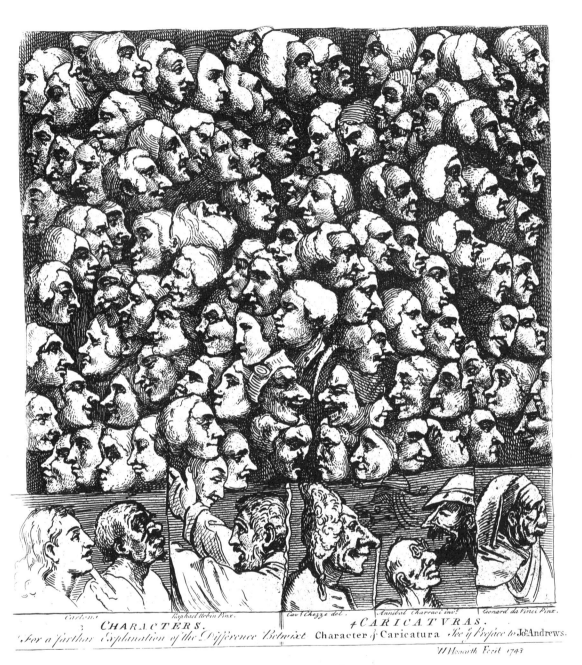

Expressive Anatomy for Comics and Narrative

ABOVE: William Hogarth's 1743 etching titled "Characters and Caricaturas."

Topffer's pursuit of graphic narration led him to focus on the grammar of facial expression or, as he called it, physiognomy. He said, "I would like to draw a face ... so that you cannot mistake my meaning." In his *Essay on Physiognomy*, the sketches he made depicted the anatomical and muscular differences in a human face. "The shape of his nose defines his capabilities and his deficiencies on the curve of his chin," Topffer said. "In the science of physiognomy, the first distinction to make is this; the expressive signs fall into two groups: permanent signs and non-permanent. Permanent signs depict dispositional traits ... we mean character, quality of reflection, alertness and intelligence ... [and] non-permanent signs depict ... accidental emotions, anxieties, laughter, rage, melancholy, scorn, surprise—in the general term, feelings."

Topffer maintained that each permanent physical characteristic taken alone was not sufficient to portray a type. He separated two indicators into permanent and non-permanent signs that are anatomical deviances singular to the person portrayed. He offers the following examples of faces with "permanent signs."

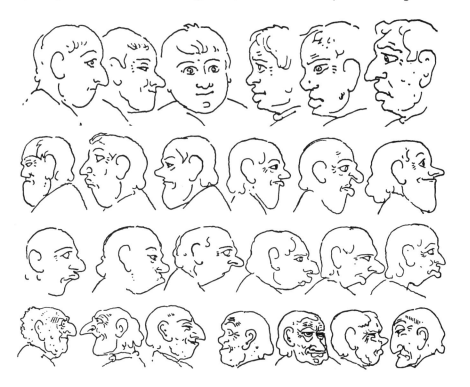

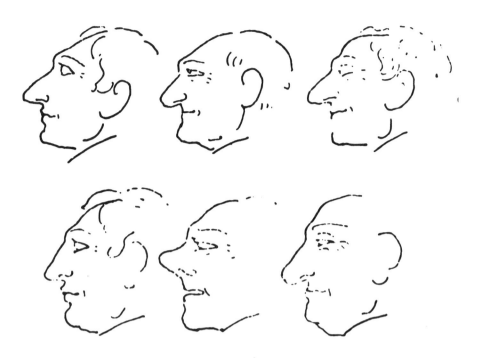

Topffer cautions, however, about the types he depicted: "Sometimes there are opposites that neutralize each other." He demonstrated this by showing a group of heads with only non-permanent facial or muscular signs that combine to over-rule the impression with a group of "fortunate traits."

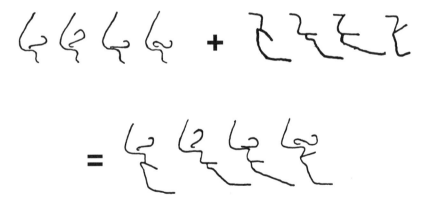

In support of his premise, Topffer observes that "the graphic symbols that enable one to project all the varied and complex expressions of the human face ... center around two anatomical variations, the nose (nostrils) and chin (jaw) in addition to the non-permanent muscular movement of the mouth."

Topffer goes on to demonstrate the application of stereotype in a narrative sequence, *The True Story of Monsieur Crépin*, which was published in 1837.

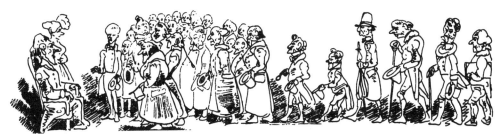

M. CRÉPIN ADVERTISES FOR A TUTOR, AND MANY APPLY FOR THE JOB.

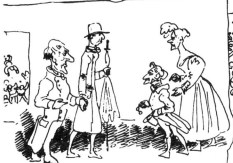

M. CRÉPIN PICKS A TUTOR HE LIKES. MME. CRÉPIN COMES IN WITH SOMEONE SHE THINKS HE WOULD LIKE BETTER.

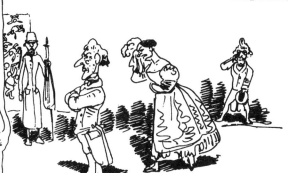

ALREADY MUCH PERPLEXED ABOUT HOW HE WILL EDUCATE HIS CHILDREN, M. CRÉPIN GETS AN ARGUMENT FROM MME CRÉPIN, WHO SCOLDS HIM FOR LETTING A CLEVER MAN GO AND TAKING A FOOL.

Topffer's work is, of course, an early form of sequential art. The application of panels to imply time and the use of balloons to carry dialogue were later devices used to eliminate the need for descriptive text under each picture.

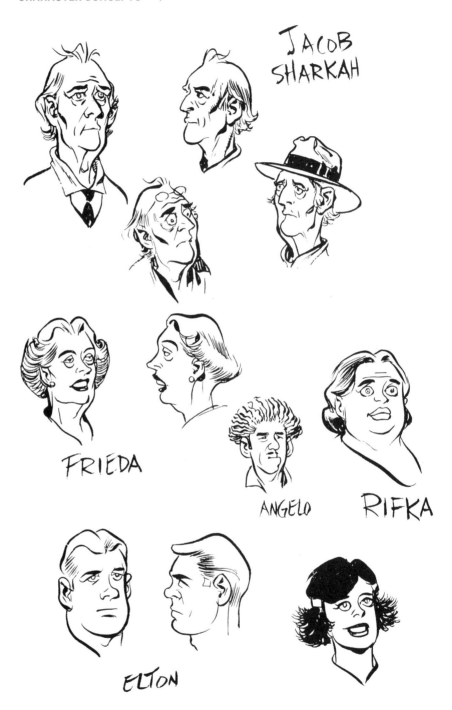

JACOB SHARKAH

FRIEDA

ANGELO

RIFKA

ELTON

Expressive Anatomy for Comics and Narrative

ABOVE: Will Eisner model sheet of Jewish, Italian and Wasp ("White, Anglo-Saxon Protestant") characters for *A Life Force*.

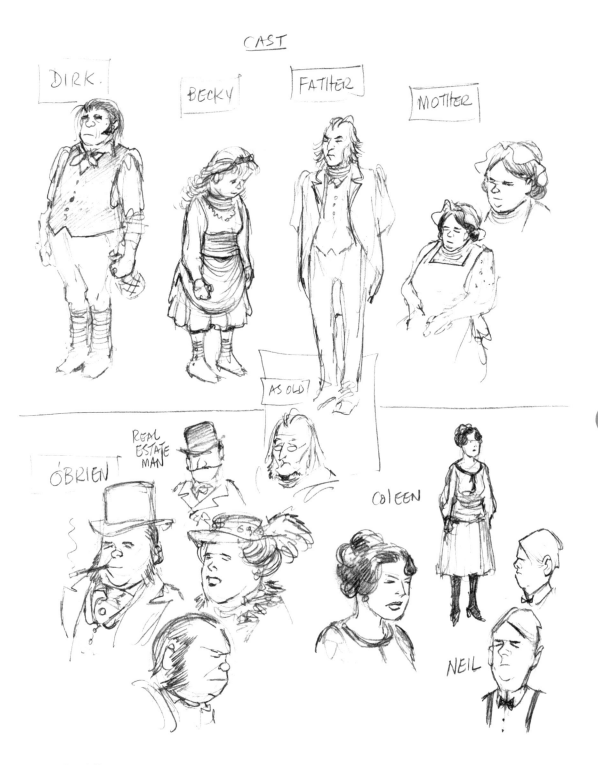

ABOVE: Two different sets of characters and types from *Dropsie Avenue: The Neighborhood*. The top group is a Dutch family and the bottom group is an Irish family.

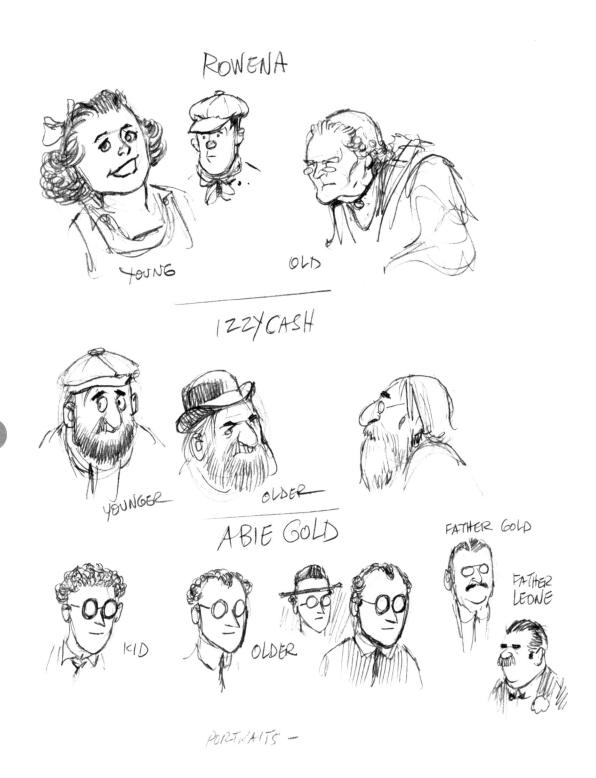

ROWENA

YOUNG OLD

IZZY CASH

YOUNGER OLDER

ABIE GOLD

KID OLDER

FATHER GOLD

FATHER LEONE

PORTRAITS —

ABOVE: A model sheet of mostly Jewish cast members of *Dropsie Avenue: The Neighborhood*, depicting three of the characters at different ages.

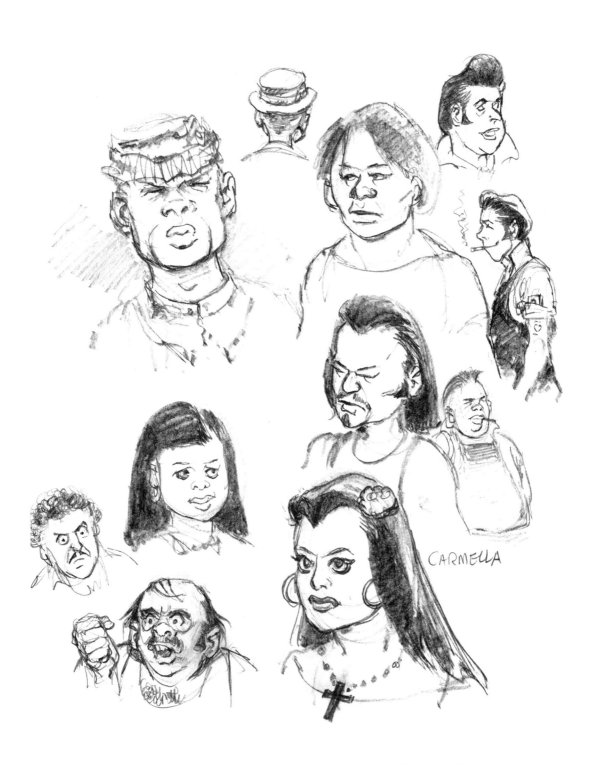

CARMELLA

ABOVE: Some of the African-American and Hispanic ethnic character types that appear in *Dropsie Avenue: The Neighborhood*.

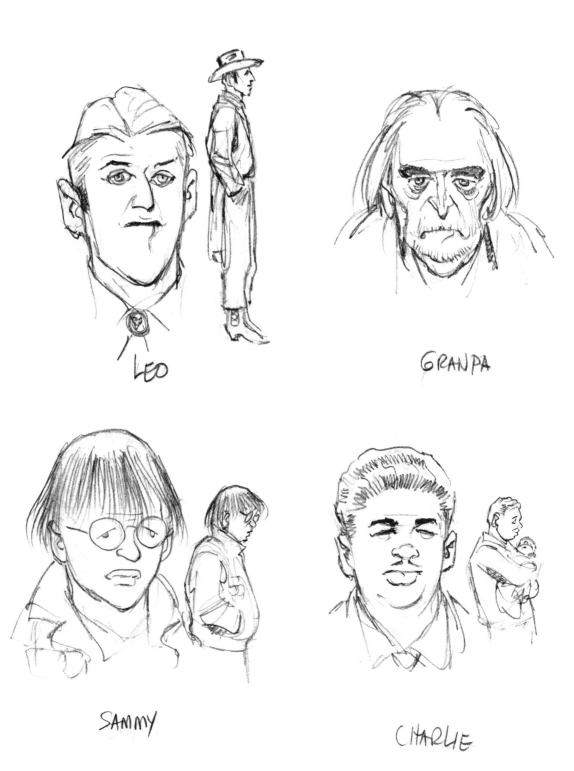

LEO

GRANPA

SAMMY

CHARLIE

ABOVE AND OPPOSITE: Two pages of portrait studies and body types of the family characters in *Family Matter*.

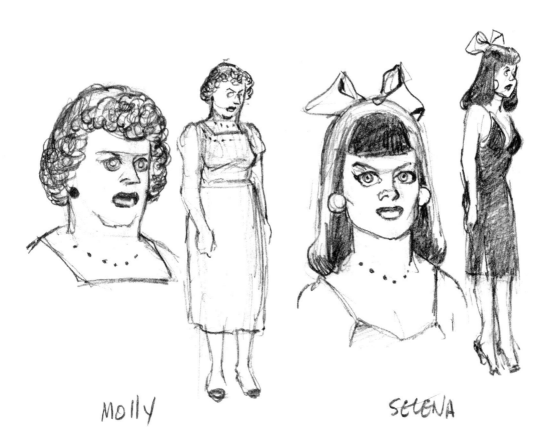

MOLLY

SELENA

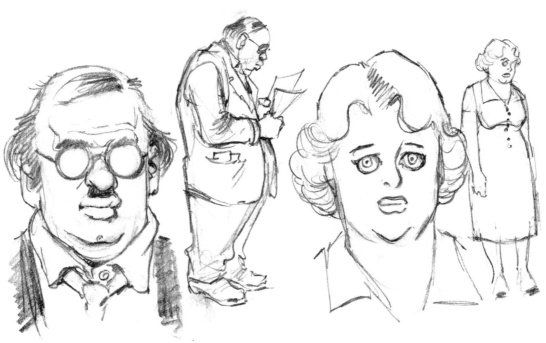

AL

GERTA

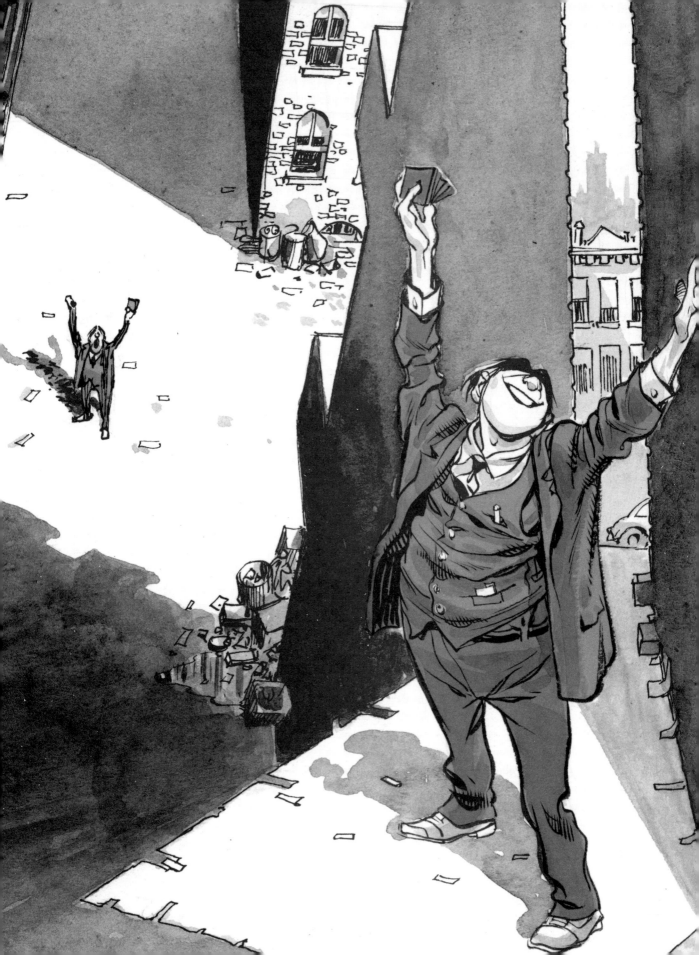

CHAPTER 16
ACTING

The depiction and employment of people in sequential art involves the artist in the process of acting. The character is an actor under the direction of the draftsman who imagines and directs the action. He must select a still image from the seamless flow of movement that makes up an action. Creating a posture or gesture that responds to an action requires an understanding derived from experience, observation, and an evaluation of the nature of each character. Age, physique and personality are factors involved. Guidelines from the static images of sequential art are similar to those employed by theatrical actors. François Delsarte (1811–1871), a French teacher of acting and singing, felt that every gesture has meaning. He analyzed movement and the classical poses of antique sculpture, which led him to develop a series of visual charts. He applied these principles to elocution and the teaching of "dramatic expression." Their usefulness has endured as a classic guide known as the Delsarte method. Essentially they revolved around the following ideas:

1. **FEEL:** To submerge yourself into the character's emotion, become him, and emulate the ability or limitations of his physique.
2. **THINK:** To know the story, understand what caused the action, and to anticipate the result.

GESTURE.

CRITERION OF THE EYES.

SPECIES. 1	3	2
1-II. Ecc.-conc.	3-II. Norm.-conc.	2-II. Conc.-conc.
Firmness.	Bad humor.	Contention of mind.
1-III. Ecc.-norm.	3-III. Norm.-norm.	2-III. Conc.-norm.
Stupor.	Passiveness.	Grief.
1-I. Ecc.-exc.	3-I. Norm.-ecc.	2-I. Conc.-ecc.
Astonishment.	Disdain.	Scorn.

(II / III / I — GENUS.)

GESTURE.

CRITERION OF THE HAND.

SPECIES. 1	3	2
1-II. Ecc.-conc.	3-II. Norm.-conc.	2-II. Conc.-conc.
Convulsive.	Tonic or power.	Conflict.
1-III. Ecc.-norm.	3-III. Norm.-norm.	2-III. Conc.-norm.
Expansive.	Abandon.	Prostration.
1-I. Ecc.-ecc.	3-I. Norm.-ecc.	2-I. Conc.-ecc.,
Exasperation.	Exaltation.	Retraction.

ABOVE AND OPPOSITE: Nineteenth-century expression charts were developed by François Delsarte analyzing theatrical gestures used in opera and, later, silent movies. Delsartian aesthetics gave spiritual connotations to movement and gave gesture priority over speech.

Expressive Anatomy for Comics and Narrative

CRITERION OF THE LEGS.

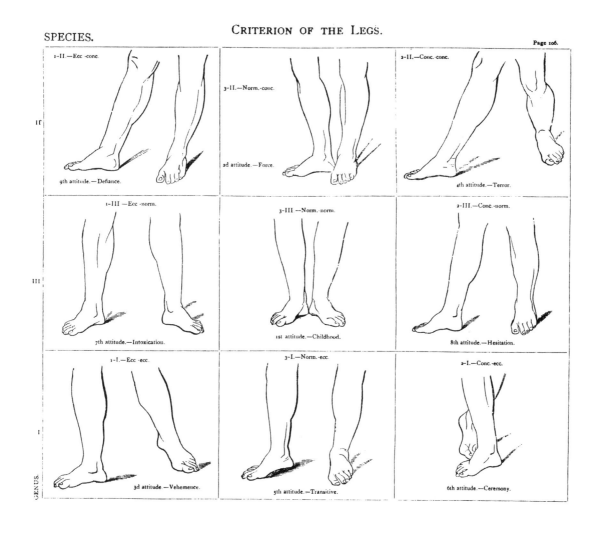

1-II.—Ecc.-conc.

9th attitude.—Defiance.

3-II.—Norm.-conc.

2d attitude.—Force.

2-II.—Conc.-conc.

4th attitude.—Terror.

1-III—Ecc.-norm.

7th attitude.—Intoxication.

3-III.—Norm.-norm.

1st attitude.—Childhood.

2-III.—Conc.-norm.

8th attitude.—Hesitation.

1-I.—Ecc.-ecc.

3d attitude.—Vehemence.

3-I.—Norm.-ecc.

5th attitude.—Transitive.

2-I.—Conc.-ecc.

6th attitude.—Ceremony.

II

III

I

GENUS.

BODY ATTITUDE

Posture and gesture are the language of internal feeling. It is important to continually study the ways in which particular poses can each communicate multiple sets of emotions given a specified context.

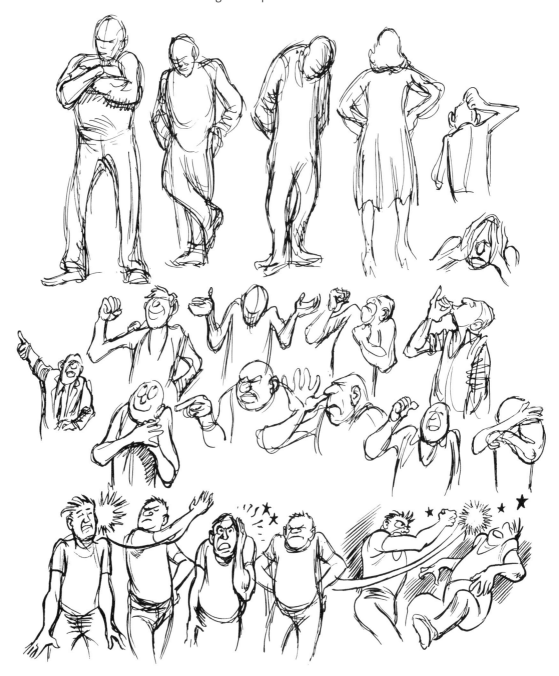

ABOVE AND FOLLOWING PAGES: A back alley evangelist preaches love using body attitudes and gestures similar to Hitler's to put his message across, beguiling, persuasive, then exulting, and ultimately demanding "love" in a three-page vignette from *New York: The Big City*.

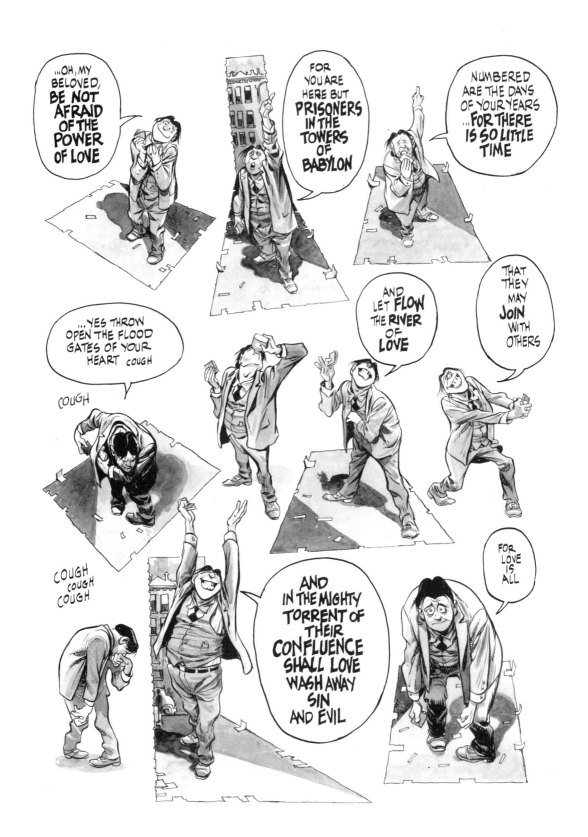

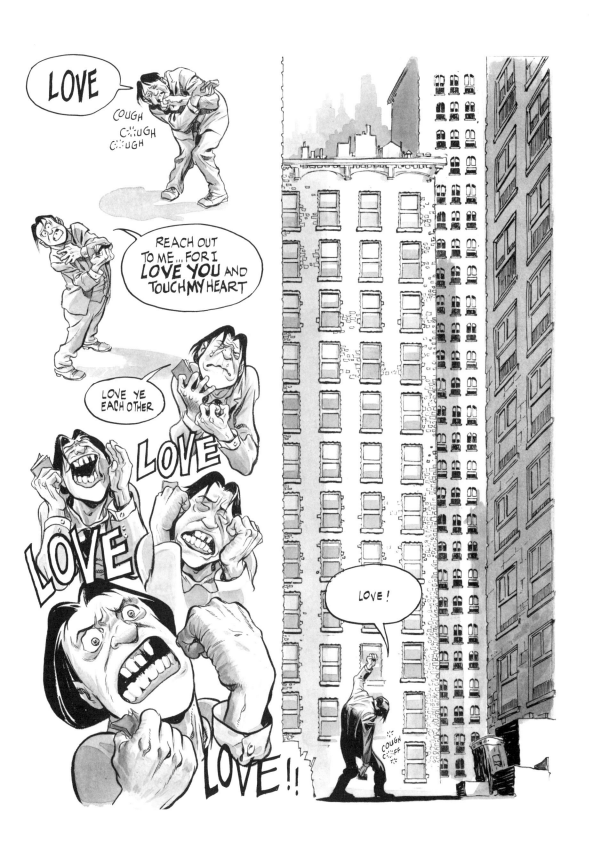

CHAPTER 17

IN PRACTICE

In the process of actually producing a narrative work of sequential art, the need to create an "interesting" page can limit the display of human expression that propels the story. To preserve the emotion it is advisable to anchor the composition of the page around the gesture or posture of the main characters. Too much focus on the gesture and posture of background characters can distract the reader from the narrative. The demand of style or technique need not limit the portrayal of emotional expression. It is the essentials of human anatomy that preserves the believability of the art whether it is realistic, exaggerated or comic.

OPPOSITE: A self-portrait of Will Eisner at the drawing board, along with some of his famous pen-and-ink creations, done to accompany an interview appearing in the November 1983 issue of *Heavy Metal* magazine.

COVER DESIGN

Covers are usually designed around the expressive postures or the provocative action of the principal actors that convey a dramatic point in the narrative. The surprise element of this particular cover composition is that it is actually a "fold-

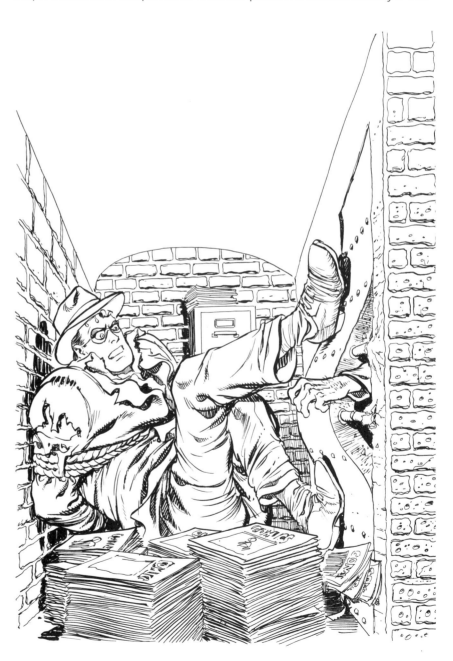

out" designed to surprise the reader with the image of a group of thugs breaking down the door on the momentarily helpless hero.

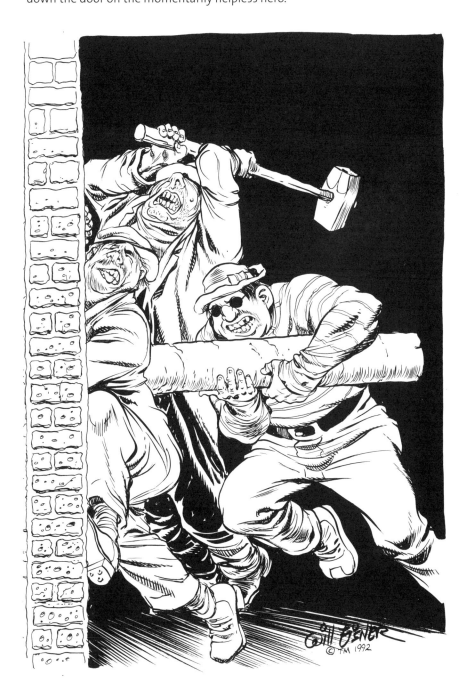

EXERCISES

Test your basic knowledge of body grammar with this simple activity. Illustrate the descriptions on the opposite page using a full figure in an emotional posture and/or making a gesture. Then, if you're up to challenging yourself by making this exercise a bit more difficult, you can try to:

a. Create a sequential situation by combining two or more descriptions with two different body types.
b. Establish a sense of place by choosing and incorporating an exterior or an interior environment.
c. Add to a sense of personality by a suggestion of an activity or a vocation, and even include a prop such as a hat, a cigarette, a letter, a water glass, an apple, a chicken leg, a bowling ball, a shovel, a golf club, a knife or a gun.

EXAMPLE: RELEASED ANGER and SUPPRESSED ANGER. Illustrate these emotions using the body grammar of a BASEBALL PLAYER.

1. The emotion is communicated by a FIGURE IN ACTION breaking a PROP in the first panel, while in the second panel, a STATIC FIGURE with closed eyes, clenched teeth, a stiff neck, tense shoulders and clenched fists reveals his internal feeling.
2. The first panel is an EXTERIOR ENVIRONMENT because there is no horizon line indicated. The second is an INTERIOR ENVIRONMENT because there are pictures hanging to indicate a wall.
3. The props are a BASEBALL BAT and a DESK and PICTURES.

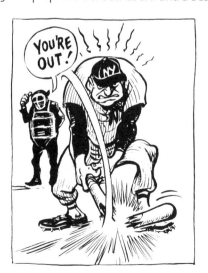 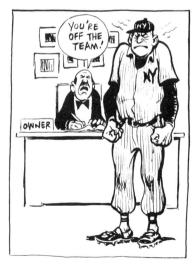

DESCRIPTION	SITUATIONS		
ANGRY	Dropped eggs	Insulted	Missed train
AFFECTIONATE	Toward a lover	Toward a baby	Toward an animal
AGHAST	At a crime	At an accident	At a loss
AGREEABLE	Closing a deal	With colleagues	At a party
ALERT	In combat	On a dark street	In a game
BAWLING	Yelling at a contest	Crying child	Reprimanding
BEWILDERED	In a crowd	In a shop	Deciding a course
BLUNDERING	Stupid act	Into danger	Wrong door
BOASTING	Self-promoting	Showing off	Bragging
BRISTLING	Protesting	Aggressive	Insulted
CAGEY	Making a deal	Playing cards	Responding
CARING	Toward a child	Toward a friend	Toward a parent
COOL	Socially	Under stress	Under threat
CHALLENGING	Military	In a debate	In an argument
CHARMING	Selling	Toward a lover	In a group
CUNNING	Negotiating	Escaping	Devious act
DARING	In combat	In romance	Under threat
DEPRESSED	Under drugs	Loss of drugs	Death of friend
DEVASTATED	Financial loss	Rejected	Destroyed home
EAGER	In romance	On a team	Socially
EMBARRASSED	Nude	In romance	Wrong room
ENJOYING	Eating	A comedy	Winning
EVADING	Unwanted overture	Pursuit	Falling object
EXCITED	By a promise	By romance	By victory
FAINTING	Sick	Drunk	From a fright
FIERCE	Threatening	Enraged	Wild
GRAVE	At a funeral	At a conference	At bad news
HARDBOILED	Policeman	Parent	Teacher
HATING	Eating a food	Prejudiced	A person
INDIGNANT	At an affront	At a snub	Rejected
JUDICIAL	As a judge	As a referee	As a parent
KIND	To a disabled person	To a beggar	To a friend
LECHEROUS	At a party	At work	Peeping tom
NERVOUS	Awaiting a result	Expecting a child	Job hunting
OLD	Man walking	Woman walking	A friend
ORNERY	Old man	Irritable woman	Boss
OUTRAGED	At a defeat	At an insult	In protest
QUARRELSOME	Man	Woman	Child
TYRANNICAL	As a sovereign	With family	At work
VEXED	Missing something	Annoyance	Nagging
WINCING	From a remark	From a blow	From pain
YOWLING	In madness	From pain	At defeat

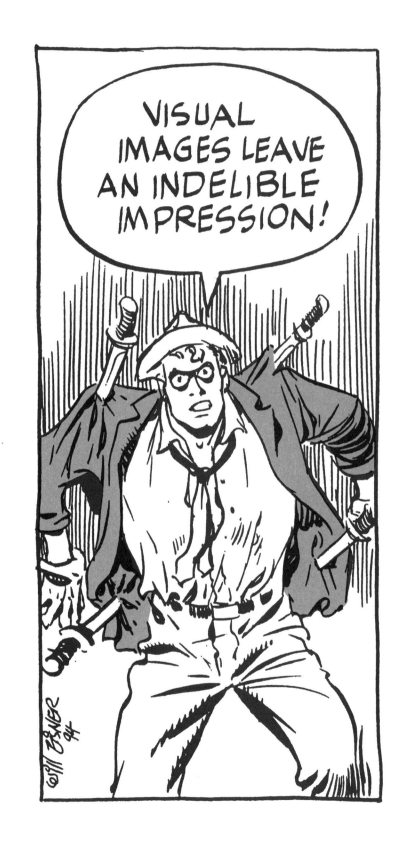

SCHOOLS OFFERING COURSES IN COMICS CREATION

• Center for Cartoon Studies, White River Junction, VT
• Joe Kubert School of Cartoon and Graphic Art, Dover, NJ
• Rhode Island School of Design, Providence, RI
• Savannah College of Art and Design, Savannah, GA
• School of Visual Arts, New York, NY

NOTE: This list is by no means exhaustive, and is intended to be a starting point for those looking for information on comics instruction. The National Association of Comics Art Educators keeps an up-to-date list of schools and resources on its Web site at www.teachingcomics.org/links.php.

WILL EISNER (1917–2005) IS UNIVERSALLY ACKNOWLEDGED AS ONE OF THE GREAT masters of comic book art, beginning as a teenager during the birth of the comic book industry in the mid-1930s. After a successful career as a packager of comic books for various publishers, he created a groundbreaking weekly newspaper comic book insert, *The Spirit,* which was syndicated worldwide for a dozen years and influenced countless other cartoonists, including Frank Miller, who wrote and directed the major motion picture based on it. In 1952, Eisner devoted himself to the then still nascent field of educational comics. Among these projects was *P*S,* a monthly technical manual utilizing comics, published by the United States Army for over two decades, and comics-based teaching material for schools. In the mid-1970s, Eisner returned to his first love, storytelling with sequential art. In 1978, he wrote and drew the pioneering graphic novel *A Contract With God.* He went on to create another twenty celebrated graphic novels. The Eisners, the comics industry's annual awards for excellence (equivalent to the Oscars in film), are named in his honor.

ALSO AVAILABLE